IMAGES
of America

GASTONIA AND GASTON COUNTY
NORTH CAROLINA

IMAGES
of America

GASTONIA AND GASTON COUNTY
NORTH CAROLINA

Piper Peters Aheron

ARCADIA
PUBLISHING

Published by Arcadia Publishing
Charleston, South Carolina

Printed in the United States of America

Library of Congress Catalog Card Number: 2001090991

For all general information contact Arcadia Publishing at:
Telephone 843-853-2070
Fax 843-853-0044
E-mail sales@arcadiapublishing.com
For customer service and orders:
Toll-Free 1-888-313-2665

Visit us on the Internet at www.arcadiapublishing.com

This book is dedicated to my beloved friend
Louise Hallmark Worthy
and the entire Herbert Worthy Clan.
Psalm 32:7 (NIV)

CONTENTS

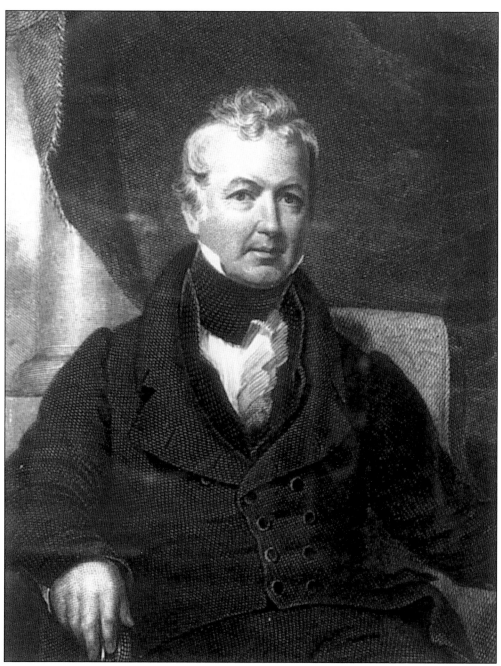

Established in 1846 by state law, Gaston County is named in honor of William Joseph Gaston, a native of New Bern, North Carolina. Gaston (1778–1844) graduated from Princeton in 1796. An attorney by 1798, Gaston served North Carolina as a speaker in the House of Commons and then as a representative in Congress. He served as State Supreme Court Justice from 1834 to 1844. While William Gaston, lyricist of *The Old North State* song, never lived within the county named for him, he donated funds for the construction of St. Joseph's Catholic Church located near the City of Mount Holly. (Courtesy of the N.C. Division of Archives and the University of North Carolina, Chapel Hill.)

INTRODUCTION

Gastonia (North Carolina) was the scene of a violent textile strike mounted by the National Textile Workers Union in 1929. First, an exchange of gunfire killed the local police chief, and then antiunion vigilantes killed Ella May Wiggins, a young mother whose songs had rallied the strikers. The presence of Communists among the union's leaders was an issue: seven strike leaders charged with murder jumped bail and sought asylum in the Soviet Union. Although the strike was broken within two weeks, in left-wing circles "Gastonia" came to stand for workers' struggle and bosses' brutality.

—*1001 Things Everyone Should Know About the South*
by John Shelton Reed and Dale Voleberg Reed
(Doubleday, 1996)

It is item number 33 in the Reeds' book, but this event in Gastonia remains a diminutive influence given the county's heritage. First, Gastonia and Gaston County were part of the Catawba Indian territories. Unfortunately, the arrival of European immigrants created an unprecedented culture clash and introduced diseases to a vulnerable population. Outnumbered, the Catawbas witnessed the Europeans confiscating fertile acreage for farms and damming the rivers to power gristmills and iron forges. By the 1750s, the British Crown loosely claimed all the land that would become North Carolina, and James Kuykendall, fearful of Tory invasions or Catawba retaliations, constructed Fort of the Point on the confluence of the South Fork and Catawba Rivers.

In 1768, Tryon County was established west of Fort of the Point. An immense landmass, Tryon was divided into Rutherford and Lincoln Counties in 1779, and by the early 19th century, pioneer life seemed hospitable. Men felled trees to create crop plots. Girls gathered eggs and tended goatherds. Boys fished the creeks and hunted rabbits while women endlessly stirred bubbling stews in black iron pots. After the families ate their meals, they recounted the heroics of local patriots like Col. James Johnston, Maj. William Chronicle, and Capt. Joseph Dickson. The Kings Mountain victory, a turning point in the Revolutionary War, was celebrated across Lincoln County and throughout the 13 colonies.

Fireside chats about the patriots, however, diminished by the 1830s as practical farmers organized judicial centers. Land transactions had to be documented. Official certificates of marriage, birth, and death had to be recorded. Lincoln County became overwhelmed by

the demands of its growing population. In 1846, state law established Gaston County out of Lincoln's southeast region. The county was named in honor of William Gaston (1778–1844), and the county seat of Dallas was mapped at the territory's center.

While Dallas buzzed with legal activity, businessmen scouted the rivers for textile mill sites. Thomas R. Tate financed Mountain Island or Tate's Mill, a four-story facility located in northeastern Gaston where the Catawba's riverbed dramatically swings into Mecklenburg and then protrudes westward again. Tate's Mill utilized waterpower, just as Woodlawn, or the Pinhook Mill, built beside the South Fork by John, Caleb, and Labon Lineberger with Jonas Hoffman, John Clemmer, and Moses Rhyne. In 1846, Larkin Stowe and sons purchased 86 acres beside the South Fork. They constructed Stowe Factory between McAdenville and Cramerton. About the same time, county post offices opened in Dallas, High Shoals, Brevard's Station, Woodlawn, the Point, Crowders Mountain, and White Pines. A multitude of jobs could be found in the villages, but most men remained on the family farm until the Confederate States of America gathered them to fight the Union.

By May 31, 1861, eleven Southern states had seceded. Gaston's three textile factories and its iron forges continued production while mothers mourned the loss of sons. Out of necessity, slaves and white women and children replaced men in the factories. One youngster, an 11-year-old son of a widowed woman, could be seen sweeping floors at Woodlawn factory. George A. Gray worked for pennies, but a mature Gray would rebuild Gaston's economy after the war. With financial assistance from local investors, Gray would spearhead the development of many textile mills including Loray, the site of the 1929 strike mounted by the National Textile Workers Union.

With the advent of railroads in the Reconstructed South, Gaston County united from High Shoals to Crowders Mountain and from Mount Holly, formerly Woodlawn, to Bessemer City. Gastonia Station was born at the crossroads, and by 1910 the city's economy thrived and its population grew.

As the 20th century approached, the Southern textile boom created labor and housing demands. Tides of new arrivals swept into communities planned and owned by the mills. Wages were good. Trolleys provided transportation until 1926 when Gaston residents again embraced progress and witnessed the completion of the state's first four-lane highway through the area. While it eased the crowded trains, the newly paved Franklin Boulevard, once known as muddy Mill Road, would forever alter the rural landscape.

This book is a brief pictorial compilation designed to provide readers with a sense of the evolution of Gastonia and Gaston County. Some of the photos have been published. Many appear here for the first time, but in all, the images revisit the optimism and the hardships, the architecture and the landscape of a city and county intricately linked to one another.

It is my hope that from beginning to end, both young and old, residents and newcomers alike will find this book a delight and that they will explore their local libraries, historical sites, and museums to learn more about the institutions, families, businesses, and civic organizations that created Gastonia and Gaston County.

Piper P. Aheron

One

FRONTIERS AND FARMS

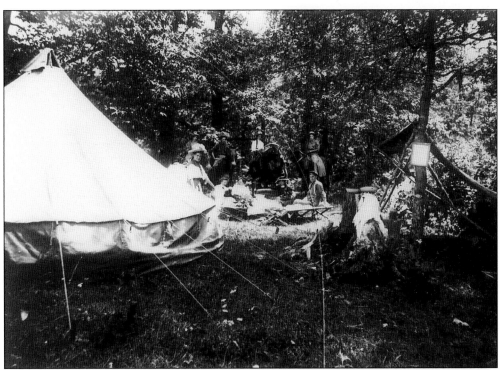

Mountains in Gaston County—Pasour Mountain, Spencer Mountain, Berry Mountain, Jackson's Knob, and Crowders Mountain—allow visitors to glimpse the area as the early settlers did. Located between Gastonia and Kings Mountain, Crowders Mountain State Park, a registered North Carolina Natural Heritage area, offers 5,095 acres of rugged peaks and breathtaking vistas. Pictured are campers from the Town of Dallas enjoying nature in an undisclosed mountain location around 1910. (Courtesy of the N.C. Division of Archives and History.)

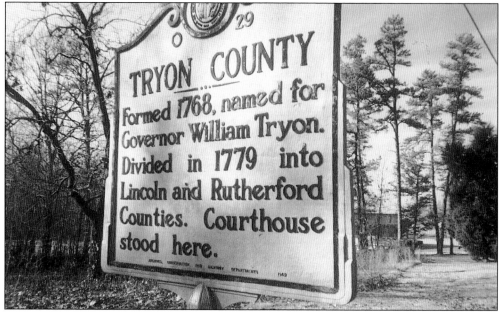

Gaston residents have salvaged two county courthouses. An exception is Tryon County Courthouse (1774–1783), located south of Cherryville on N.C. 274. The courthouse, also the residence of Christian Mauney, provided storage for county records and served as a jail. As for Tryon County, the area was named for the hated William Tryon, a colonial North Carolina governor appointed by Great Britain's King George. Tryon levied taxes on farmers in a territory that would eventually become present-day Lincoln and Gaston Counties. Tryon needed the funds to construct a palace, but outraged farmers revolted. (Photo by P.E. Peters.)

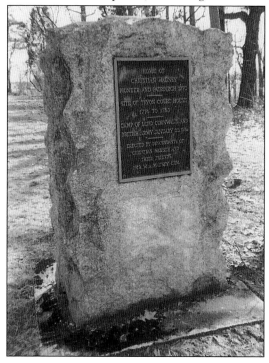

Farmers declared their independence from British tyranny in the Tryon Resolves of 1775. In October 1780, the Battle of Kings Mountain began in the War of Independence. A 1919 stone commemorative on the courthouse site celebrates the signers of the Tryon Resolves. It also gives a brief history of the land that was utilized as a campsite by Lord Cornwalis and the British Army on January 23, 1781. (Photo by P.E. Peters; courtesy of the Col. Frederick Hambright Chapter of the Daughters of the American Revolution.)

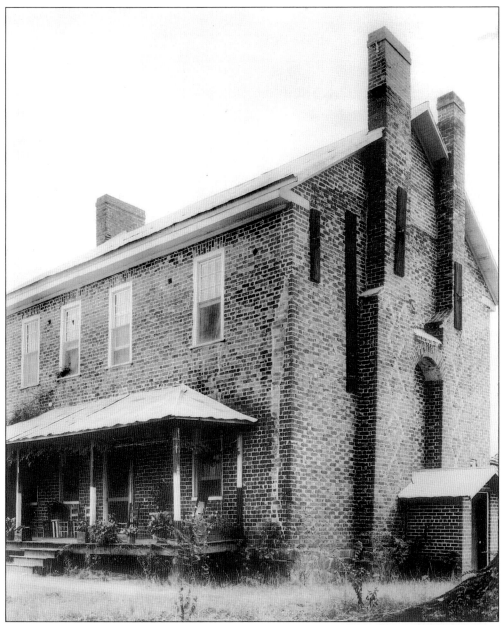

Johnston House, or Oak Grove, near Lucia was laid in Flemish Bond. Exterior chimneys boasted diamond-pattern brickwork believed to be the handiwork of James Johnston, a 39-year-old militia colonel and a ruling elder of Unity Presbyterian Church. Johnston built this structure on the west bank of the Catawba and north of Tooles Ford in 1782. He made wooden molds for the brick and sun-dried the clay. He fabricated the porch and the roof, and when the building and its unique smokestacks were completed, Johnston enjoyed a peaceful life of farming. He also served the territory as a political leader. (Courtesy of the N.C. Collection, University of North Carolina Library at Chapel Hill.)

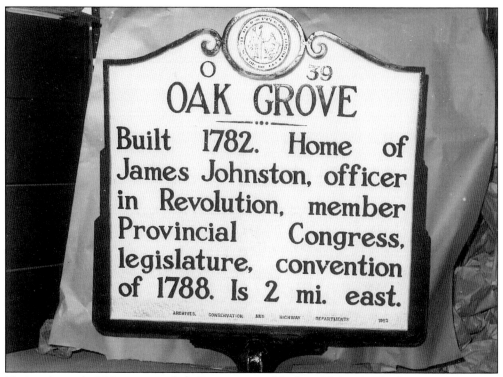

O 39

OAK GROVE

Built 1782. Home of James Johnston, officer in Revolution, member Provincial Congress, legislature, convention of 1788. Is 2 mi. east.

ARCHIVES, CONSERVATION AND HIGHWAY DEPARTMENTS 1952

During the early 20th century, Oak Grove was visible from N.C. 16. The house is now gone, and the land caters to gross urban development. Even the historic marker, photographed here in 1952 shortly after casting, disappeared from the highway when N.C. 16 was widened. The site of Oak Grove is difficult for historians and tourists to find, but it is located close to Lucia, a community north of Mount Holly in Gaston County. (Courtesy of the N.C. Division of Archives and History.)

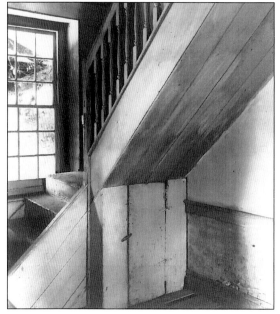

Some Gaston county patriots relocated out of North Carolina after the War of Independence. Capts. Joseph Dickson and George Rutledge migrated to Tennessee. Others moved to South Carolina. Col. James Johnston, however, died at his plantation in 1805 near the community of Lucia. He was in his mid-60s, but as a veteran of the battles at Ramsour's Mill and Kings Mountain, Johnston was respected throughout Gaston and Lincoln. This view shows the primitive interior of Oak Grove, which no longer stands. (Courtesy of the N.C. Collection, University of North Carolina Library at Chapel Hill.)

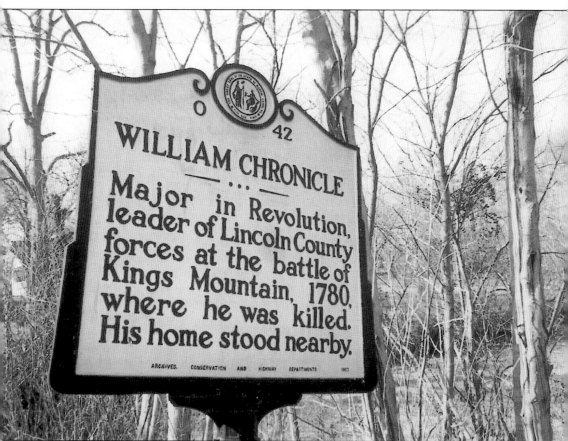

O
42

WILLIAM CHRONICLE

— ... —

Major in Revolution, leader of Lincoln County forces at the battle of Kings Mountain, 1780, where he was killed. His home stood nearby.

ARCHIVES, CONSERVATION AND HIGHWAY DEPARTMENTS 1953

A 14-year-old boy, the son of a South Fork (now Belmont) farmer, armed himself to fight the British-led Cherokees in the winter of 1776. The boy, William Chronicle, fought beside adults and, by age 17, returned home a veteran of war. Resourceful as well as charming, William recruited men for his own private fighting regiment. The group served with Gen. Benjamin Lincoln's patriots who engaged the British in Savannah only to lose the battle. Lincoln retreated to Charleston. He surrendered to the British there, but Chronicle and a few of his men escaped to Belmont. Chronicle quickly reorganized his regiment, dubbed the 20 men the "South Fork Boys," and confronted British Maj. Patrick Ferguson at Kings Mountain less than 20 miles from Belmont in October 1780. Chronicle's men and the volunteers from Gaston took the brunt of Ferguson's fire. Chronicle was shot out of his saddle. He died at age 20, but the South Fork Boys were victorious. Currently, a marker stands on N.C. 7 within Belmont's city limits, but the Chronicle farmhouse is long gone. Industrialist R.L. Stowe named Chronicle Mills for young William. A mural of William and his South Fork Boys exists in Belmont's city hall at 115 North Main. The Works Progress Administration constructed the city hall in 1937. (Photo by P.E. Peters.)

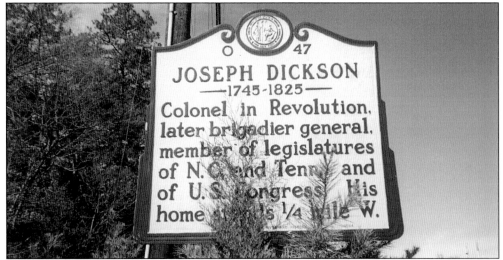

At the Battle of Kings Mountain, Tories shot Maj. William Chronicle out of his saddle. Capt. Joseph Dickson spent no time mourning the loss of his comrade. He rallied the volunteers of South Fork as the rest of the Lincoln-Gaston patriots supported a furious offensive. In a volley of musket fire, the South Fork Boys brought down British major Patrick Ferguson. They defeated the British Army, and Capt. Joseph Dickson moved from the area in 1803 to live in Tennessee. He died at age 80. Throughout the Revolution, Dickson's farm served as a gathering spot for Gaston patriots interested in practicing military maneuvers. All that remains of the site, however, is this marker on N.C. 27 just northwest of Mount Holly. (Photo by P.E. Peters.)

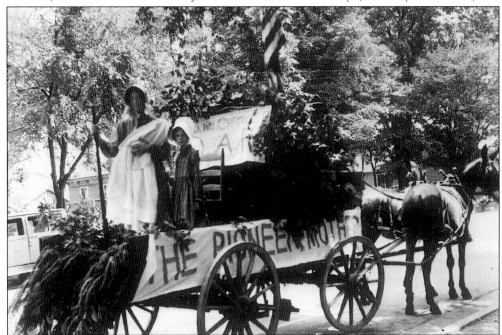

In Belmont, the Daughters of the American Revolution (DAR) float "Pioneer Mother" took first prize in a 1927 parade. The grandfather of President Abraham Lincoln is listed on the 1790 census of Lincoln County, which later would be divided to create Gaston County. (Courtesy of the N.C. Division of Archives and History.)

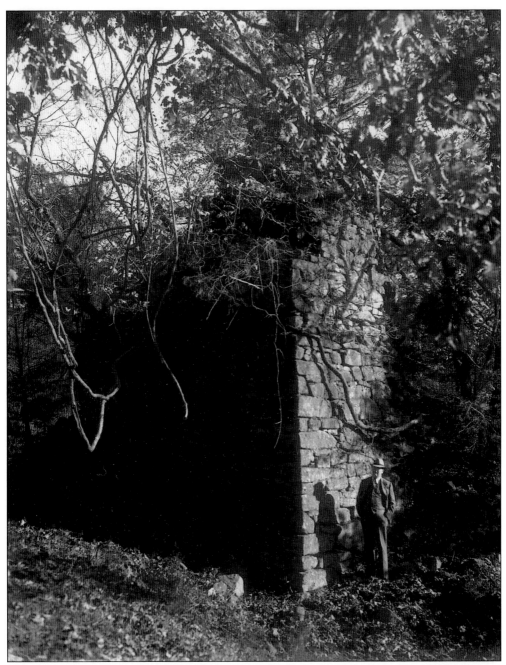

This rock pile, pictured in the 1930s, near Bessemer City is the remains of John Sloan's Washington Forge, a furnace that extracted iron ore for pioneers. During the War of Independence, the primitive foundry supplied iron skillets, kettles, wash pots, and nails as well as artillery to the patriots. Col. James Johnston gathered his militia at the furnace, which became Ben Ormand's property in a 1754 land grant. These kinds of furnaces, including the ones operated by John Fulenwider, were productive until the third quarter of the 19th century. Gold, mica, lime, and other metals beside iron ore were routinely extracted from Gaston County and sold on the open market. (Courtesy of the N.C. Division of Archives and History.)

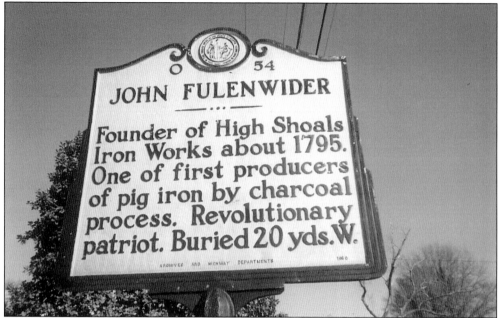

A member of the Rowan County militia at Ramsour's Mill and Kings Mountain, John Fulenwider began processing iron ore about 1795. The native of Switzerland also found gold on his land, but the iron proved more profitable. This plaque on Old Highway 321 designates Fulenwider's grave, which is near a white, wooden church constructed in 1902. The picturesque High Shoals Methodist sanctuary features typical Gothic pointed-arch windows and a diagonally set, square tower, one of the few in the county. By the 1920s, most county churches utilized a cruciform plan. (Photo by P.E. Peters.)

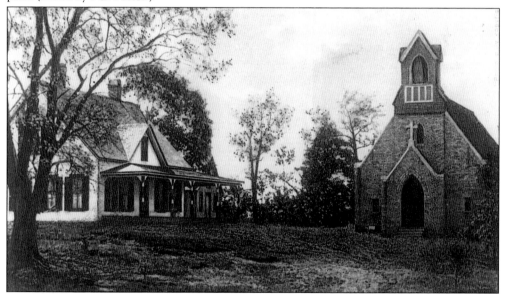

John Fulenwider's High Shoals Iron Works did not survive the Reconstruction era that followed the Civil War. Village workers, however, continued building the picturesque hillside town, and in 1973, High Shoals was incorporated. Pictured above are the 1910 schoolhouse, rectory, and Episcopal church. (Courtesy of the N.C. Division of Archives and History.)

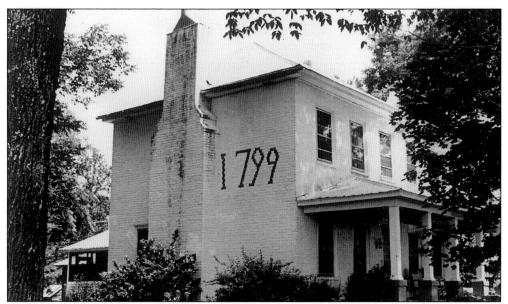

Civil War troops drilled in the fields surrounding the Thomas Rhyne House, located at 1221 Stanley-Lucia Road near Stanley. Commonly referred to as the "1799 House," the brick home is the county's only surviving 18th-century house laid in Flemish Bond. The date is worked into the bricks on the west elevation. The original interior, however, was destroyed by fire in 1850. The interior was rebuilt by a local cabinetmaker named Peter Eddleman, and it remains private property. (Courtesy of Haithcox Photography, public domain.)

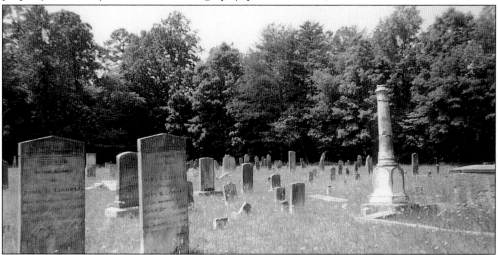

Established in 1764, Goshen Cemetery on Woodlawn Road in North Belmont is the resting place for Revolutionary War soldiers Robert Andrew, Hugh Berry, Richard Berry, Samuel Caldwell, Thomas Campbell, Hugh Erwin, Peter Fite, John Glenn, James Gullick, Thomas Hanks, Thomas Henry, Samuel Martin, Alexander Moore, John Moore, George Oliver, William Rankin, Samuel Rankin, James Rutledge, Abraham Scott, and John Smith. Goshen Presbyterian wooden chapel, built around 1760, existed until the 1970s when it was torn down to make way for a parking lot. William Gaston Chapter, DAR once maintained the site, but tombstones are now crumbling like the ancient walls surrounding the burial plots. Even a historical marker has vanished from the site. (Photo by Piper P. Aheron.)

Donations from William Gaston and other devout Catholics allowed for the construction of this simple chapel in the Mountain Island area of Gaston County. In 1843, Bishop I.A. Reynolds of the Diocese of Charleston, South Carolina dedicated St. Joseph's. The church was the only place for Catholic worship in Gaston County until the construction of Belmont Abbey's first chapel in the 1880s. Located three miles north of the City of Mount Holly, St. Joseph's and its cemetery remain the oldest standing Catholic facility in North Carolina. (Courtesy of P.E. Peters.)

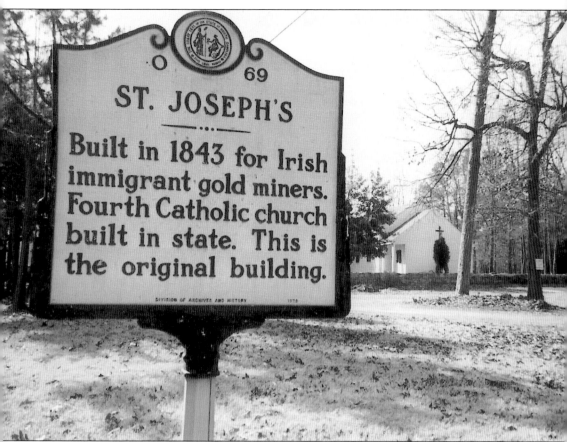

In 1828, Dr. Elisha Mitchell, a North Carolina University professor, examined ore and mineral deposits within the territory that would become the present-day Gaston, Lincoln, and Cleveland Counties. Mitchell found gold, but other men like Chevalier Riva de Finola, a Catholic Italian, established and worked mines on properties west of Tuckaseege Ford and the Catawba River. Several Irish families joined de Finola's efforts. They met in a chapel at de Finola's home for Mass until farmer William Lonegan donated a land tract for a new church. Catholics throughout the South contributed cash for the building's construction, and among the most generous givers was Judge William Gaston for whom the county is named. (Photo by P.E. Peters.)

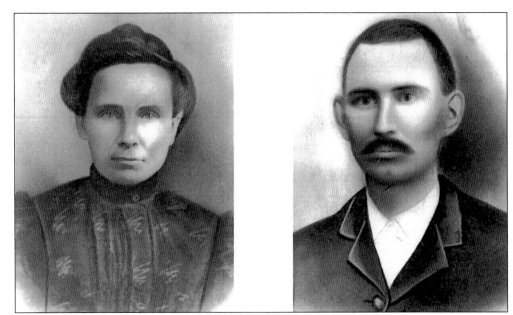

The first European immigrants to settle in Gaston were from Scotland, Ireland, England, and Germany. Most were farmers who did not own slaves. They settled near the rivers, but by the time of Reconstruction, cities had formed. Robert Preston Stewart (1867–1899) married Mary Ann McClure (1880–1907), and his posterity would not only live in Gastonia, they would build it during the middle of the 20th century. This couple is buried at Tates Chapel United Methodist Church cemetery on Chapel Grove Road in Gastonia. (Courtesy of Jim Stewart.)

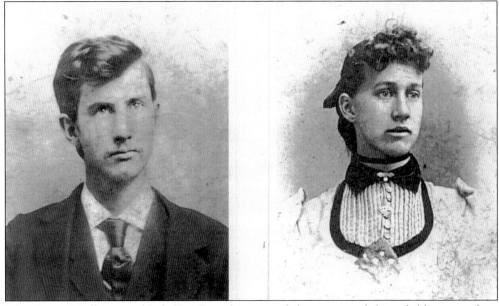

John Cicero Wells married Lela Etta Froneberger, and the two raised their children on a farm just south of Gastonia that remains in the family. Currently, Harry Wells operates the farm. In many of Gaston's pioneer families, including the Stowes and the Linebergers, land is considered vital to the succeeding generations. It is cherished and passed down as an heirloom whenever possible. (Courtesy of Jim Stewart.)

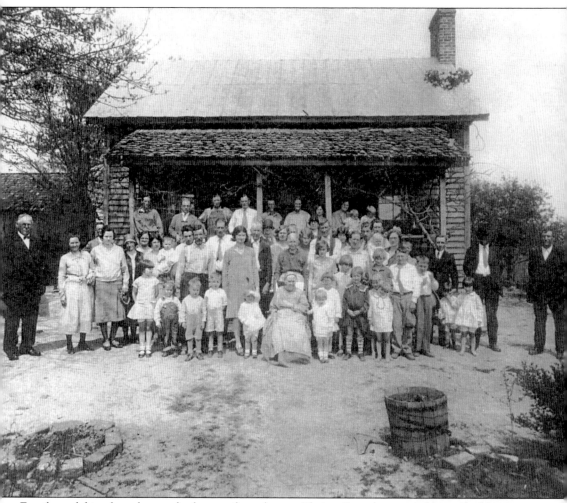

Family and friends gather at the home of gentleman Christy Froneberger and his wife, Mattie Froneberger, for a birthday dinner in honor of 91-year-old Betsy Crawford Wells. From left to right, the ten people on the porch are as follows: Roy Crawford, unidentified, William McClure, D.L. Stewart, unidentified, Hattie Crawford, Lillian Crawford, Beulah holding babies Steve and J. H. Stewart. Other family members represented are Lizzie Crawford, Julia Crawford, Ethel Froneberger McClure, Elma Stewart, Ida Wells, baby Charles Wells Jr., Robert Froneberger, Miles Wells, Bertha Wells Pendlenton, Rich Wells Weir, Mattie Kennedy, Florence Wells Weir. Vida Lee Wells, Roe Wells, Vinnie Crawford, Edna Wells, Lelia Wells, Campbell Wells, Charlie Wells, Essie Wells, Lloyd Stewart, Hunter Crawford, Dr. W.P. Grier, Frank Crawford, and Rich Wells. Among the children enjoying the festivities are Lorina Crawford, Junior Ecklerod, Robert Stewart, Melvin Pendlenton Jr., Dorthy Stewart, and Cora Wells. Frances Stewart, Mildred Stewart, Campbell Stewart, and Paul Stewart are also in the photo, taken on April 13, 1930. Betsy Crawford Wells lived until 1933. She is seated before her party guests. Currently, the farm remains in the family. (Courtesy of Jim Stewart.)

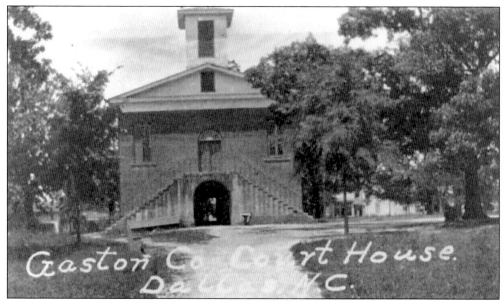

Dallas appeared on state maps in 1847 after political leaders determined that the county's center, the Jesse Holland property, would be county seat. Holland's farmhouse served as a temporary court while slaves and craftsmen constructed a permanent facility in 1848. The completed, brick county courthouse partially burned in 1874. It was quickly rebuilt utilizing original architectural elements. The 1875 courthouse still stands on the square in Dallas surrounded by antiquated buildings like the Hoffman Hotel and the old jail. (Courtesy of Haithcox Photography, public domain.)

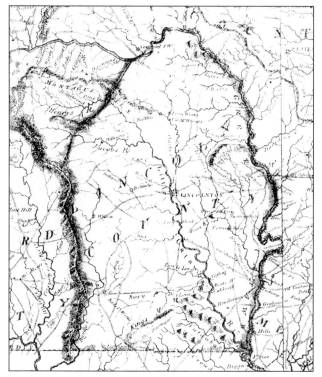

Lincoln County is depicted in this survey map split to create Lincoln and Gaston Counties. The river graphed as "Little Catawba" is now called the South Fork River. Notice there is no Dallas. Although farmers lived in the area, a new county seat would be created shortly after state legislators established the new county in 1846. (Courtesy of the N.C. Division of Archives and History.)

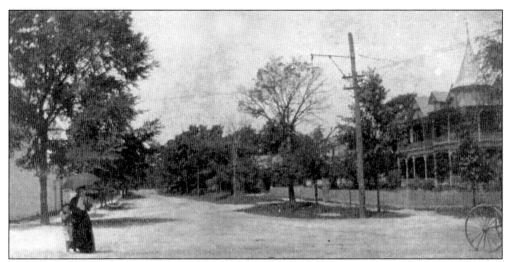

In 1846, Gaston County purchased farmland for the development of Dallas, a town named for Vice President George Mifflin Dallas, advocate of the United States' involvement in the liberation of Texas from Mexico. The county bought 75 acres for $50. Once the Civil War began, Confederate troops gathered in the town's square. There, they would march to Brevard's Station, now called Stanley, to catch the train to the battlefields. Local brawls between Unionists and Rebels were common during this period, but overall Gaston County remained peaceful through much of the war. This photo was taken in the 1890s. (Courtesy of Haithcox Photography, public domain.)

In 1852 Daniel Hoffman bought Lot #5 in Dallas and built this hotel, which had 44 rooms. In 1866 the hotel became the property of Jonas Hoffman. Jonas and his 16 children took care of guests during Dallas court sessions. When Jonas died, his son Puett managed the business. In 1945 the first county historical society organized, and then it reorganized in 1952 in order to continue educating people about local history and preservation. Located at 131 West Main in Dallas, the Hoffman House, a Greek Revival building embellished with a Victorian porch, today serves as an exhibit hall and gallery for members of the Gaston County Museum of Art and History. The state's largest collection of horse-drawn vehicles is preserved in the Daniel Stowe Carriage House behind the hotel. (Courtesy of Haithcox Photography, public domain.)

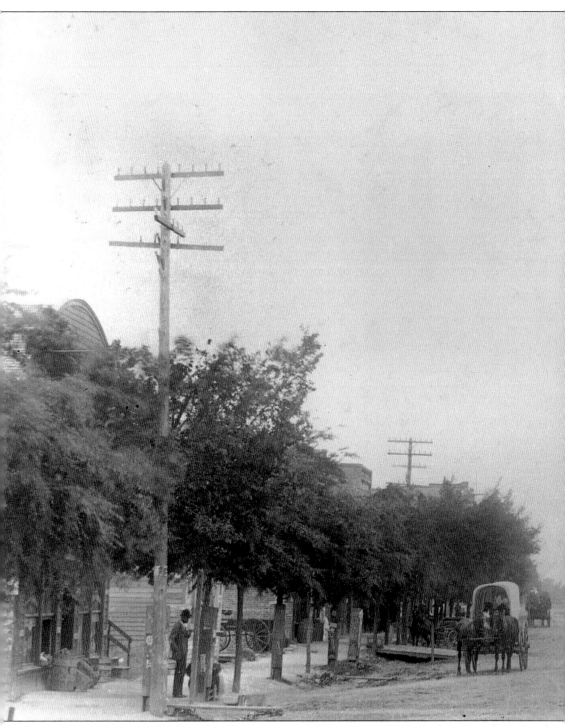

A covered wagon rolls down dusty Main Avenue of Gastonia in 1897. At that time, the railroad was the town's center, and it was located near the John Craig homestead. Roughly 200 people lived on small farms within city limits. A handful of stores provided hardware and supplies, but the town, approximately 20 miles from Charlotte, grew from a reconstructed economy after

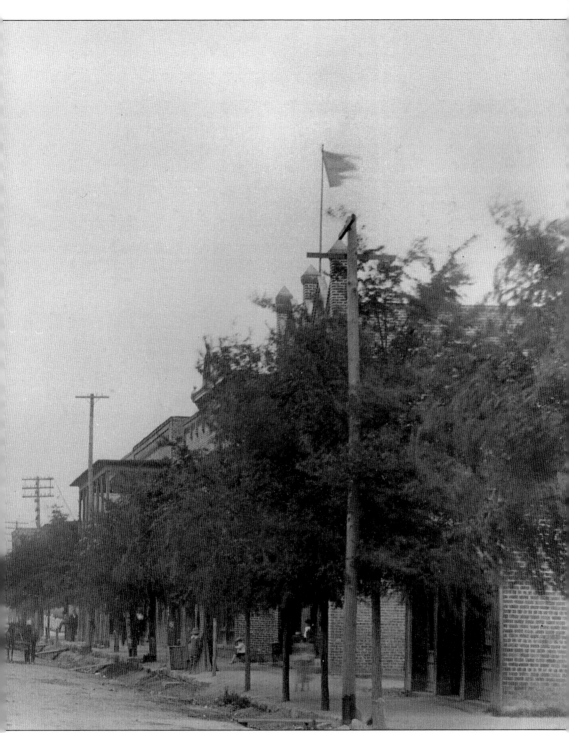

the War between the States. Textile mills and railroad traffic provided supplemental income to poverty-stricken farmers and their families. Gradually, the farms disappeared. (Courtesy of Haithcox Photography, public domain.)

Europeans from Ireland, Scotland, and Germany constructed log cabins along the Catawba River as early as the 1740s. Fred D. Hoffman and Moses H. Rhyne owned a store one mile west of Tuckaseege Ford in an area called Woodlawn, named for a 1767 house and its basement, which served as a local jail. Woodlawn eventually incorporated as Mount Holly. It is one of

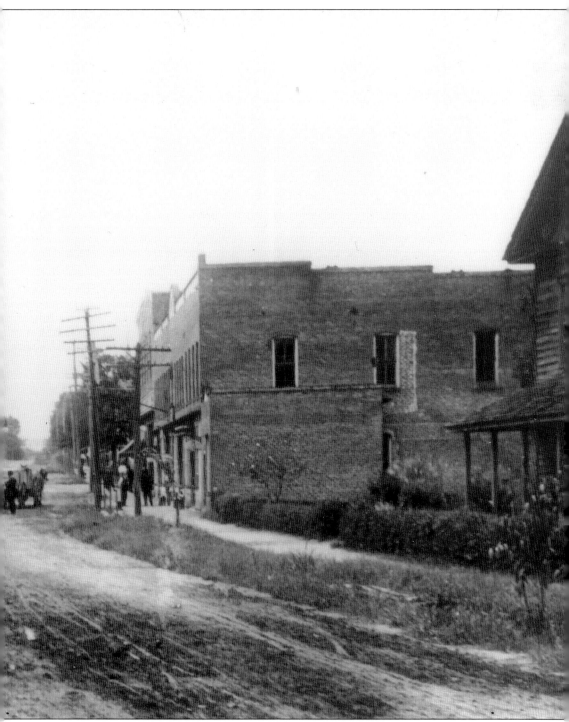

Gaston's oldest cities, and railroads of the Seaboard and the Piedmont and Northern first laid their lines here. Pictured is a buggy and buckboard loaded with freight and rolling toward the railroad track in Mount Holly. (Courtesy of Haithcox Photography, public domain.)

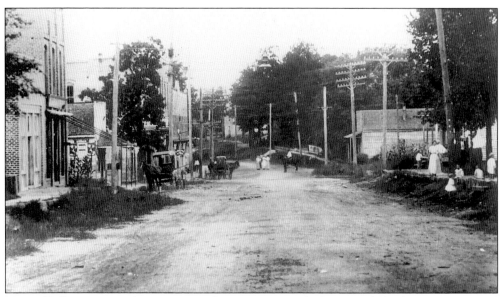

Mount Holly retains its charm in spite of its proximity to the big city of Charlotte. Interstate 85 is located at the city's southern limits. N.C. 16 is on its northern limits, and the CSX railroad, N.C. 27, and N.C. 273 pass through the central part of the contemporary city. Pictured above is another view of downtown Mount Holly at the beginning of the 20th century. (Courtesy of Haithcox Photography, public domain.)

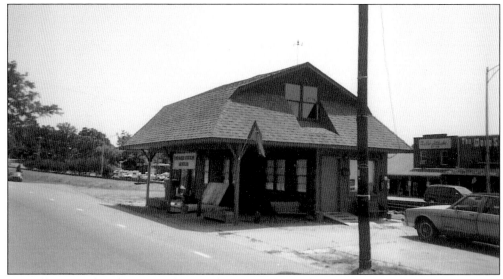

Post office records indicate Stanley Creek organized as early as 1856. Four years later a railroad extension from Wilmington to Charlotte to Rutherford reached property owned by two brothers, Robert and Ephraim Brevard. A depot called Brevard's Station was constructed at the site, and then the post office transferred to the depot. In 1861, Gaston men who volunteered to fight for the Confederacy met at Brevard's Station. There, they boarded a train to Raleigh and joined the 16th North Carolina Regiment. The depot continued as an origination point for Gaston Confederates. In 1879, the town of Brevard's Station incorporated, but in 1893 the residents changed its name to Stanley Creek. In 1911, the villagers again changed the name, this time to Stanley. (Photo by P.E. Peters.)

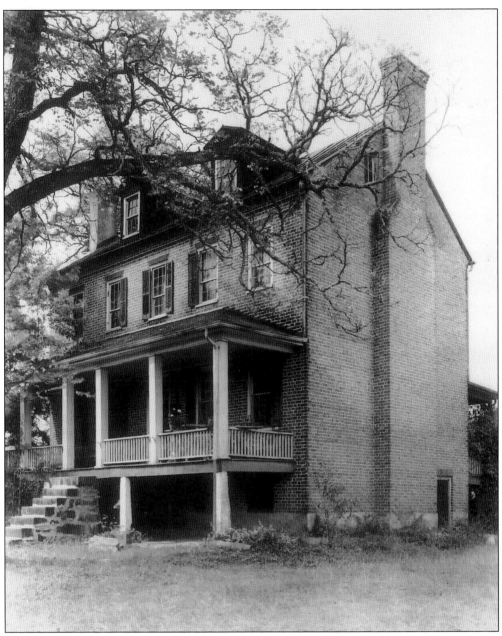

Bessemer City's origins date to the 18th century when the pig iron forge created items for the patriots. Later, John Wooten laid railroad tracks near a general store. He called the store and the depot Wooten's Station. John Askew Smith, a tobacco businessman, left Reidsville, North Carolina and visited the Whetstone Mountain area of Wooten's Station. Smith purchased 1,700 acres of land and hired W.R. Richardson, an engineer, to plan and construct a town that would eventually be named Bessemer City, incorporated in 1846. Although Smith founded Southern Cotton Mill, or Reeves Brothers/Osage Mills, textiles would not be the city's only income. Mining continued to produce iron ore, and presently, the area is rich with lithium. Pictured is J.A. Smith's house in the early 1900s. (Courtesy of the N.C. Collection, University of North Carolina at Chapel Hill.)

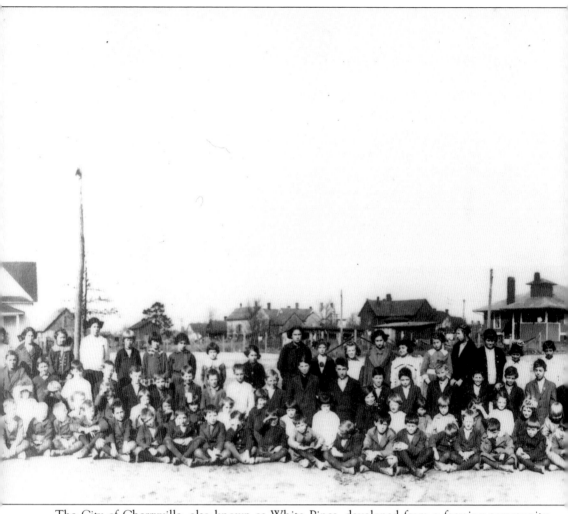

The City of Cherryville, also known as White Pines, developed from a farming community into a village at a stagecoach junction known as Old Post Road, the main thoroughfare between Salisbury, North Carolina and Spartanburg, South Carolina. By 1853, businesses at the intersection thrived. In 1862, railroad transportation arrived. The city's first cotton mill

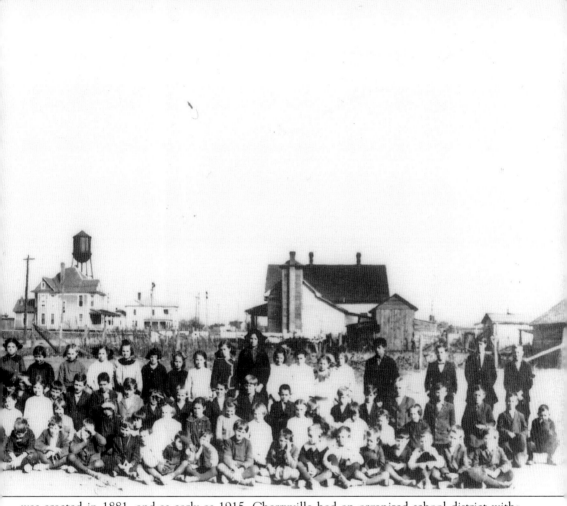

was erected in 1881, and as early as 1915, Cherryville had an organized school district with legal charter. In this 1914 view, students pose before a Cherryville school built around 1905. According to records, the school was in use until 1924. (Courtesy of the N.C. Division of Archives and History.)

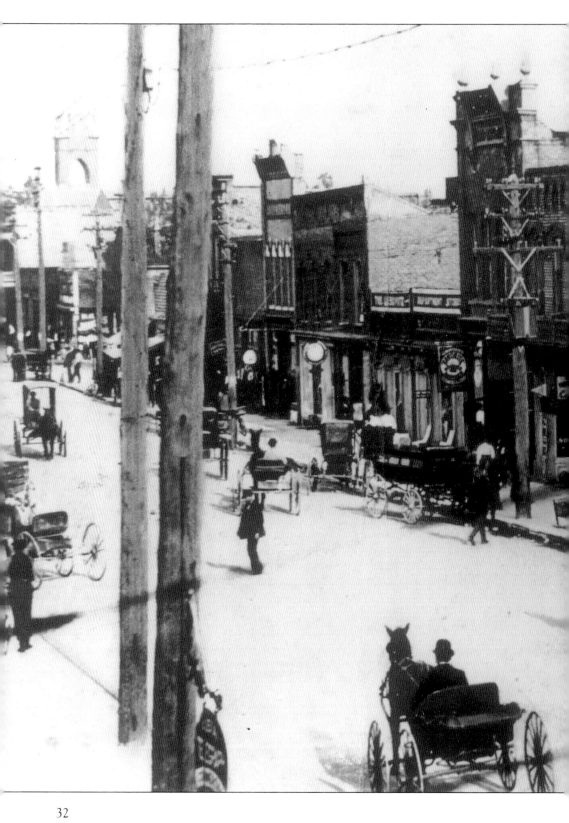

In 1900 Gastonia physically surrounded the railroad tracks that created it. The depot and hotels were the first things visitors saw upon arrival and not the 1911 courthouse. In fact, according to a 1910 article in the *Gaston Gazette*, land along busy Main Street proved too costly for the new courthouse. County officials opted for a less expensive tract on South Street just off Main, and for this reason, the courthouse is not the focal point of town, a tradition in most Southern cities. In Dallas, however, visitors can still see that the old courthouse remains at the center of activities.

Robert Leeper and other settlers from Virginia built a fort at the confluence of the Catawba and South Fork Rivers in the 1750s. By 1865 a community of farmers existed at the Point, but there was no organized village. In 1872 the railroad extended west from Mecklenburg into Gaston. A water tank and fuel station called Garibaldi led to the formation of present-

day Belmont. In 1924, Fort Mill powerdam impounded water around Belmont and created Lake Wylie. Pictured is a railroad trestle over the Catawba River. The 1920s jalopies rumble toward Belmont. (Courtesy of the N.C. Collection, University of North Carolina Library at Chapel Hill.)

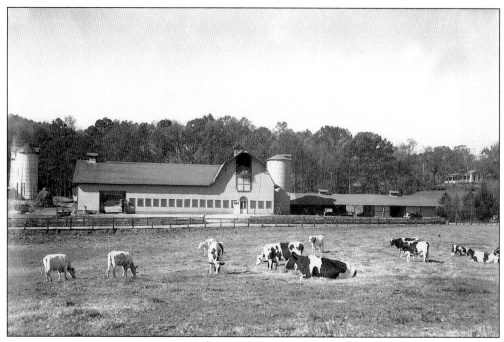

A dairy at Cramerton, pictured here c. 1938, was a non-profit entity for the benefit of Stuart Cramer's mill employees. The herd was comprised of Holstein-Fresian cows. Milk was sold to mill employees at 10¢ a quart, 6¢ a pint, and 3¢ a half-pint. According to Cramerton historian Autrey L. VanPelt, families of five or more children received free milk. The dairy no longer stands. (Courtesy of the N.C. Division of Archives and History.)

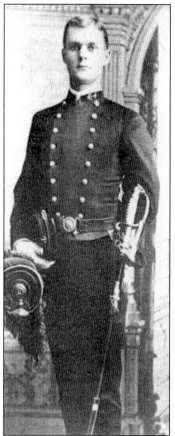

Stuart Warren Cramer (1868–1940) graduated from the U.S. Naval Academy in 1888. The Thomasville, North Carolina native studied at Columbia University in 1889; he then returned home where he began a career in textiles. In 1906 Cramer studied his mill's work environment, and he planned an interior coolant system, primitive by modern invention, that he named "air conditioning." Air conditioning would not merely comfort employees, but it would cool machinery, preventing spark fires that easily reduced the best-built cotton mills into a pile of ash and rubble.

Two

CITIES AND INDUSTRIES

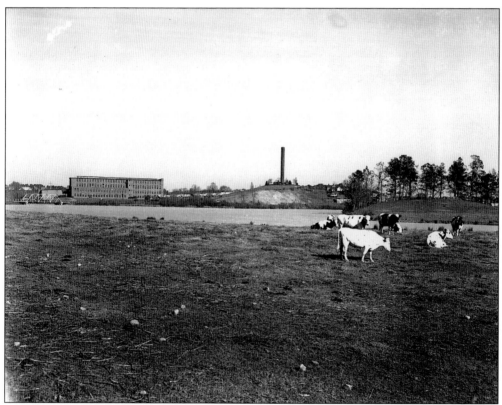

In 1906, J.H. Mays and his investors built a spinning mill near the South Fork and called it Mayworth. In 1910, Stuart Warren Cramer, a textile engineer, purchased Maysworth. He changed its name to Cramerton Mills in 1922. In 1923 Mayflower Weave Mill was built, and an extension was created in 1927. In 1946, Burlington Industries purchased the mills that had produced cloth and materials for World War II soldiers. This photo was taken *c.* 1938. (Courtesy of the N.C. Division of Archives and History.)

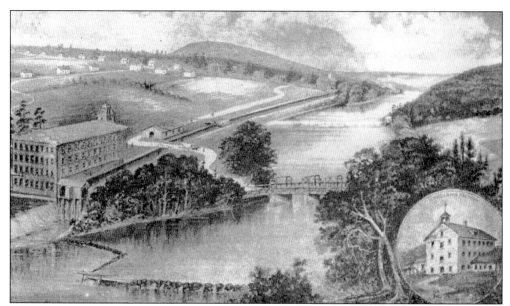

In the northeastern corner of Gaston, the Catawba riverbed dramatically swings into Mecklenburg and then protrudes westward again as water rushes south over the rocky shoals referred to as Mountain Island. By 1853, Tate's Mill, or Mountain Island Mill, and the Woodlawn, or Pinhook Mill (pictured above), both operated in the region known as Riverbend. Jasper Stowe's Factory, built on the lower South Fork River, also operated. Tate's Mill vanished in the floods of 1916. In 1923 Duke Power erected a hydroelectric plant at Mountain Island. (Courtesy of the N.C. Division of Archives and History.)

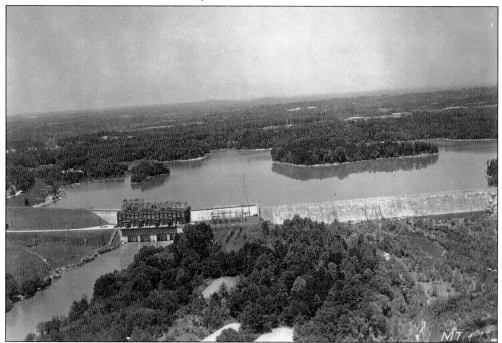

A plane flies over Mountain Island in May 1951 and a snapshot is made of the aging hydroelectric plant. (Courtesy of the N.C. Division of Archives and History.)

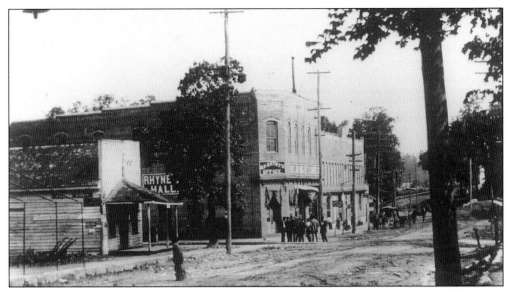

The men of Mount Holly meet in front of A.P. Rhyne's office in Rhyne Hall. A.P. Rhyne built and owned the first electric system in Mount Holly. A generator at Rhyne's Mount Holly Cotton Mill on Dutchman's Creek, a tributary of the Catawba River, supplied power to A.P. Rhyne's home at 140 North Main and to his office at the Holland Drug Company. Rhyne Hall, a large auditorium complete with a stage, provided a place for school graduation and commencement ceremonies. Musicals performed at Rhyne Hall catered to whites, and it is believed that Rhyne provided the hall as a beneficial civic gesture. (Courtesy of Haithcox Photography, public domain.)

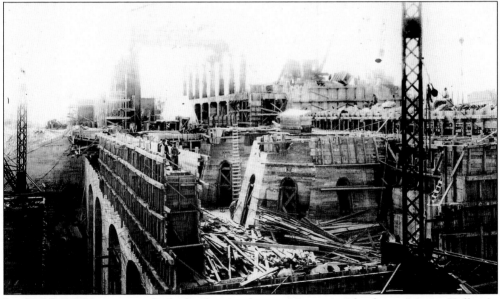

In 1923 Duke Power erected a hydroelectric plant at Mountain Island near Mount Holly. At the time the plant was under construction, seven new textile manufacturers opened for business in Gaston County. In 1924, a Fort Mill, South Carolina power dam impounded waters of the Catawba and the South Fork and formed Lake Wylie. In 1956 Duke Power built Plant Allen in Belmont. (Courtesy of the N.C. Division of Archives and History.)

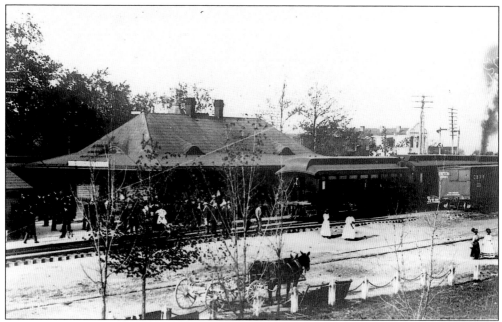

Atlanta and Charlotte Airline Railroad extended westward from Mecklenburg County into Gaston in 1870. As construction neared Dallas, surveyors and builders of the railroad bed pressed the township for construction funds for bridges across several creeks. Municipal financing would have secured a railroad station in Dallas, but funds could not be raised, so railroad executives opted to construct Gastonia Station in 1872. Gastonia Station and its tiny population, located four miles south of Dallas, incorporated into the City of Gastonia five years later. This photo was taken c. 1908. (Courtesy of the N.C. Division of Archives and History.)

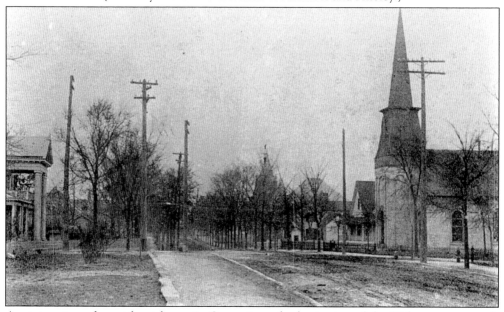

A winter view of a residential area in Gastonia at the beginning of the 20th century reveals a neighborhood of peace beneath church steeples. Streets were wide and lined by leafless hardwoods. (Courtesy of Haithcox Photography, public domain.)

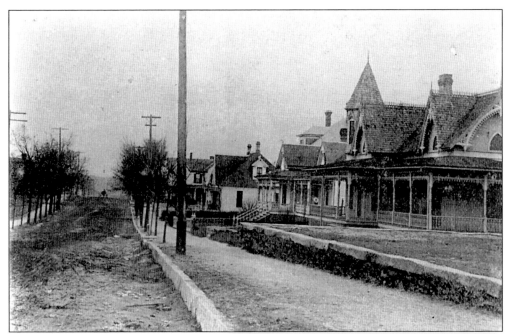

A buggy rolls by the beautiful houses lining the clay street of downtown Gastonia. Downtown Gastonia still has a residential area along its Main Street. (Courtesy of Haithcox Photography, public domain.)

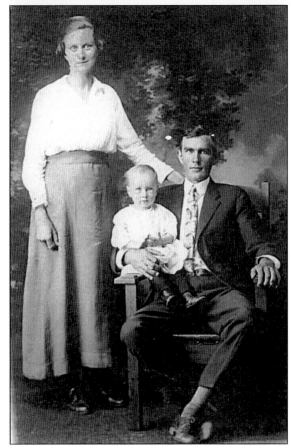

Essie Mae Wells Stewart stands beside her husband, David Lester Stewart, and their baby boy Campbell Lester Stewart in this 1919 photograph. At that time Gaston County thrived on an economy of textile-related industries. (Courtesy of Jim Stewart.)

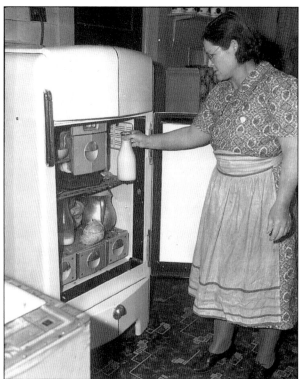

From the 1900s to 1946, mill managers within the county provided employees with good housing, utilities, food, schools, and even churches. Here, Mrs. Reese shows off her modern kitchen in 1939. The Reeses enjoyed the benefits of employment with Cramerton Mills, which also supplied milk and produce at discounted prices. Letters by the Cramers indicate the family remained sensitive to the needs of their beautiful industrial community even after the mill was sold to Burlington in 1946. In 1940, unincorporated Cramerton had a population of 3,280. In 1990, the town's population numbered 2,285. (Courtesy of the N.C. Division of Archives and History.)

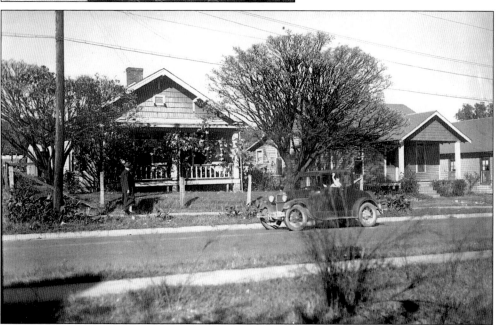

Originally mapped as Highway 20, Franklin Boulevard connects Charlotte with Gastonia and passes through a number of villages including Lowell, Cramerton, McAdenville, and Belmont. Highway 20 opened in 1926 as the state's first four-lane road. It serves as U.S. Highway 29/74 today, but in this *c.* 1938 image, a jalopy exits off Highway 20 and passes Cramerton cottages. (Courtesy of the N.C. Division of Archives and History and the N.C. Dept. of Transportation.)

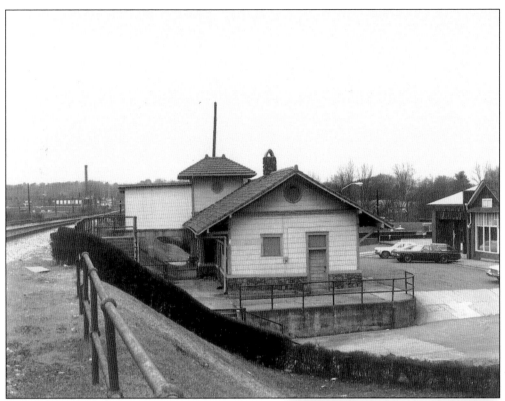

Built before 1916, Cramerton's Passenger and Freight Railroad Depot sat opposite the town's shopping district described as the shortest Main Street in *Ripley's Believe It Or Not* and in the *Guinness Book of World Records*. According to local historian Autrey L. VanPelt, men gathered at the depot between mill shifts. They played chess and listened to baseball games whenever Stuart Cramer brought his radio into town. The depot no longer stands, but Main Street enjoys brisk business. (Courtesy of the N.C. Division of Archives and History.)

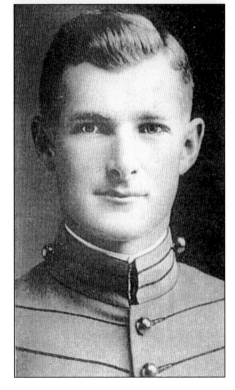

Stuart W. Cramer Jr. (1892–1957) graduated from the U.S. Military Academy at West Point. He served in World War I, earning the rank of major. In 1939, Major Cramer became the president of Cramerton Mills after serving beside his father as a director. According to a 1946 letter by Stuart W. Cramer Jr., the family could no longer retain the mill due to his health problems and industries' sharp inflation after World War II. Cramerton was sold to Burlington Mills Corporation.

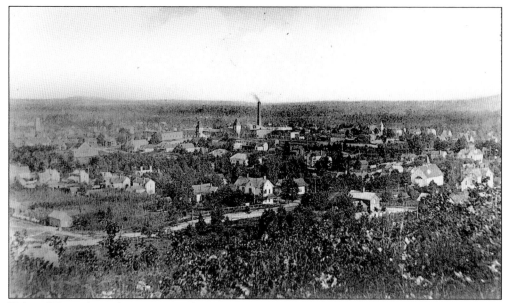

Tales of Tory ghosts haunting nearby Kings Mountain entertained hardy pioneers that settled in a whistlestop first named Wooten Station. A tobacco businessman from Reidsville, John Askew Smith arrived in 1891. Smith built the first cotton mill in 1895. He renamed the city for the first child born within its boundaries. Baby girl Bessemer McGill (Mrs. David Mobley) was born in 1892 just prior to the town receiving its charter from the General Assembly. Smith also used the name "Bessemer" for the high-quality iron ore mined in the area. (Courtesy of the N.C. Division of Archives and History.)

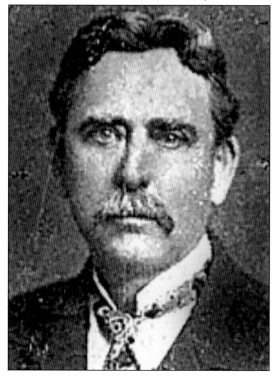

John Askew Smith founded Bessemer City. He came to the area in 1891 but European immigrants had resided in the area prior to the War of Independence. Artifacts from the Ormand Forge and the Ramseur's gristmill give testimony to the pioneer spirits that haunt the hills and valleys surrounding the town.

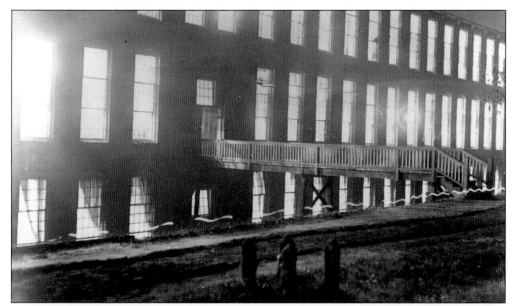

A stretch of the upper South Fork foams loudly over rocks. Called High Shoals, the currents once operated the bellows and hammers that molded melted ore into pig iron utensils. By 1893 the foundry there ceased profitable operation, and a cotton mill was built. With turbines churning electricity, the new High Shoals Mill, or High Shoals Manufacturing, could function 24 hours a day, as seen in this 1920s image. By the end of World War I, the highly productive mill employed blacks as well as whites. Six years later profits slumped. The mill merged with Manville-Jenckes Loray. In 1941 the mill created the town's first public water system, but the town did not incorporate until 1972. (Courtesy of the N.C. Division of Archives and History.)

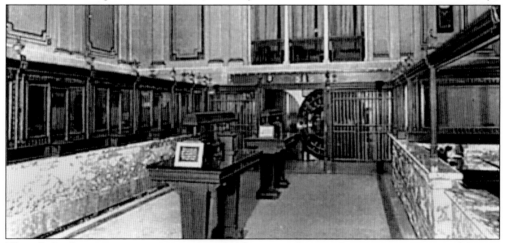

Though banking is not as prominent an industry in Gaston County as it is in neighboring Mecklenburg, in 1905, Citizens National Bank organized in Gastonia. During the Great Depression, Gastonia's population amounted to 17,093 with half of its labor force unemployed. The First National Bank, People's Bank, Gaston Loan & Trust Company, and Bank of Dallas closed. Citizen's National Bank struggled and survived to reorganize in 1933. By the mid-1930s, Gastonia and Gaston County's economy churned again. The neoclassical-style Citizens National still stands on West Avenue and was designed by local architect Hugh White. The interior is seen here c. 1920. (Courtesy of the N.C. Division of Archives and History.)

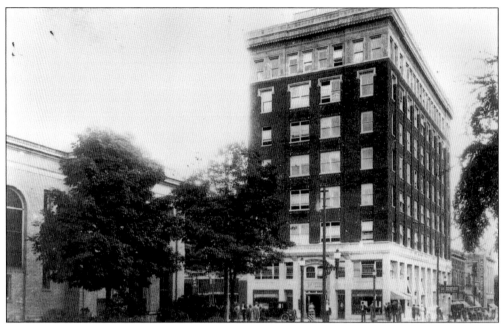

Financial institutions were firmly established within the county by 1887. Supported by savvy local entrepreneurs, Gastonia banks retained and disbursed capital primarily for the benefit of the county's textile mills. Third National Bank operated on the first floor of the Commercial Building erected in 1923 and one of two Gastonia skyscrapers. In 1926, a merger with Third National created Commercial Bank and Trust. The building, with its marble lobby and exterior brick-and-granite construction, still stands at 195 West Main Avenue. It is listed on the National Register of Historic Places. (Courtesy of the N.C. Division of Archives and History.)

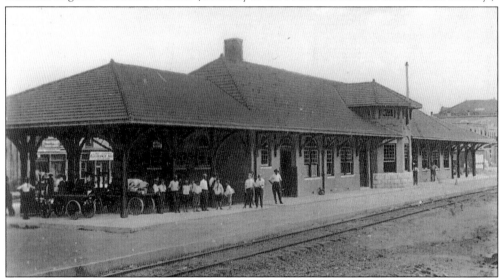

When the act to incorporate Gastonia passed the 1877 General Assembly, the fixed city limits were described as one square mile to be determined by closing the lines from the center of the crossing of the Richmond & Atlanta Railroad and the Chester & Lenoir Railroad. Ironically, the city defined by railroads could not preserve its Mission-style Southern Railway Passenger Station. (Courtesy of the N.C. Division of Archives and History.)

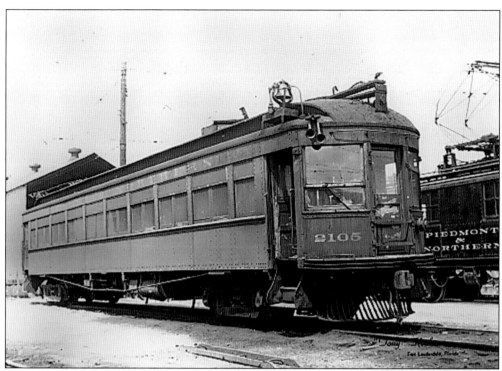

From 1911 to 1948, trolley cars ran from Gastonia to Charlotte and back again. Operated by Piedmont and Northern Railroad, the trolley cars traveled on tracks that ran the length of Franklin Boulevard. As automobiles became more affordable, people purchased them and quit riding on the trolleys. (Courtesy of the N.C. Division of Archives and History.)

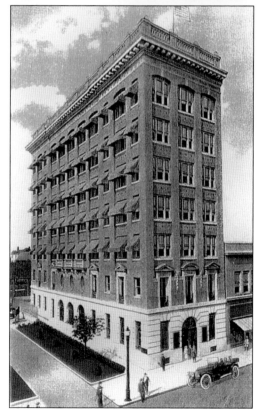

Designed by Wilson & Sompayrac of Columbia, South Carolina, First National Bank Building, erected 1916–1917, housed the financial institution on the first two floors until the Great Depression. The upper five floors were leased as offices, a premium address for county attorneys. By the middle of the 20th century, Gaston folks called the tower the Lawyers' Building. The landmark still stands with its exterior "bearded men" watching over the city block of 168–170 West Main Street in Gastonia. It is listed on the National Register of Historic Places. (Courtesy of the City of Gastonia Downtown Development.)

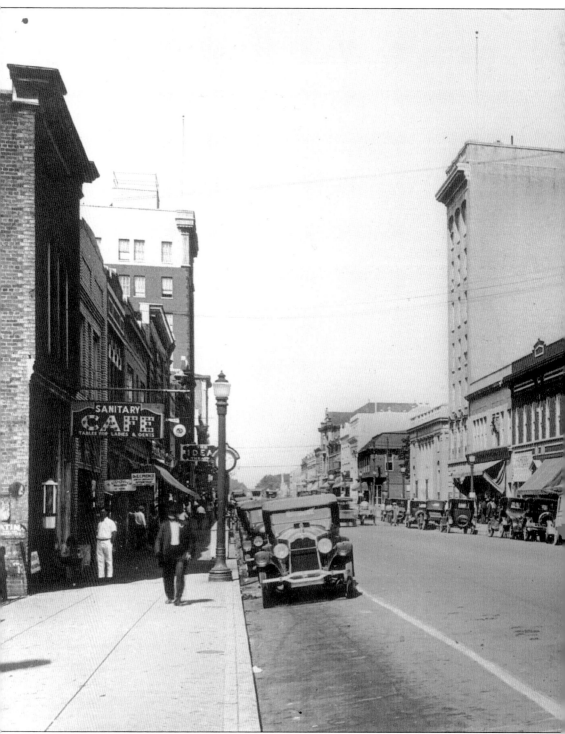

The unique architectural character of Gastonia and Gaston County can catch the eye of Hollywood. Buildings along Gastonia's Main Avenue as well as adjoining neighborhoods have served as the setting for the Hallmark Hall of Fame movie *Saint Maybe* and the CBS miniseries

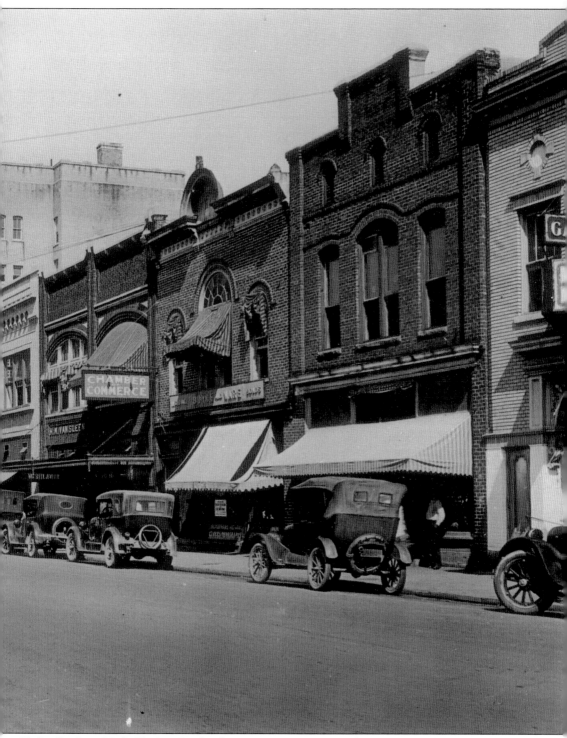

Shake, Rattle and Roll. The Last Brickmaker in America, starring Sidney Poitier and airing on CBS in May 2001, was shot at Central Elementary School near downtown. This photo of Gastonia was taken *c.* 1929. (Courtesy of Haithcox Photography, public domain.)

The Washington, D.C. firm of Frank Milburn & Heister designed this courthouse along with 15 others in North Carolina. Milburn utilized tan brick to create architectural details like ionic columns, deep porticos, and dentil cornices. In 1998, the interior burned after offices moved to a new facility on Long Avenue in Gastonia. In January 2001, the National Trust for Historic Preservation, National Park Service, and the White House Millennium Council named the 1911 Gaston County Courthouse, located at 151 South Street, as a project worth preserving in the book *Save America's Treasures*. The distinction has the capacity to generate public and private funding for restoration and preservation of the 1911 courthouse and downtown Gastonia. (Photo by P.E. Peters.)

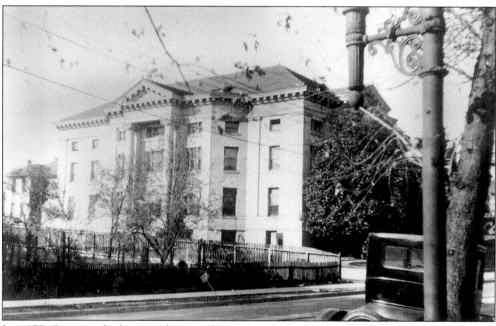

In 1877 Gastonia had a population of 200, but by 1900 the city's population swelled to 4,610. Voters went to the polls three times in eight years to determine the county's center of government. Dallas won twice until 1909 when voters elected Gastonia as the county seat. A four-story, neoclassical revival–style courthouse was constructed and completed by 1911 at a cost of $75,000. This particular courthouse, pictured c. 1918, was remodeled in 1946, 1954, 1961, and 1967. It sits on property that once belonged to an African-American citizen named Earl S. Sanders. (Courtesy of the N.C. Division of Archives and History.)

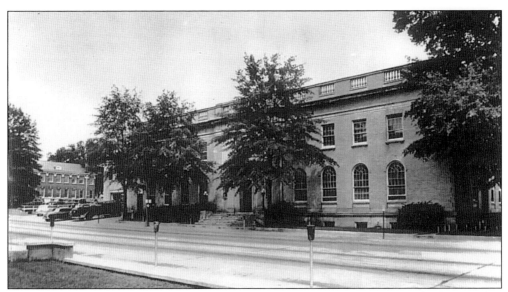

Gaston County and Gastonia flourished between 1900 and 1929. Factories ran 24 hours a day, and in 1926, Hugh White, a local architect, designed this Renaissance Revival–style City Hall as a compliment to the nearby county courthouse. Through the course of the 20th century, the City Hall building housed the public library, the police station, and the YMCA until those units could secure construction funds for separate quarters. The building, with its barrel-vaulted ceiling on the first floor, remains on 240 West Franklin Avenue. (Courtesy of the City of Gastonia Downtown Development.)

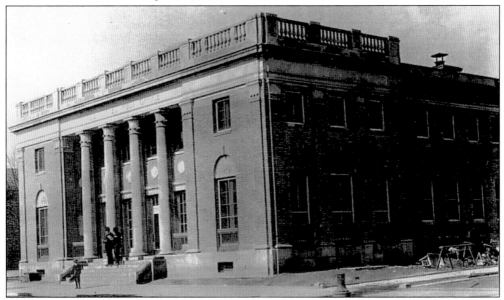

This early 20th century post office of steel and brick was replaced in 1935 by the structure at 301 West Main in Gastonia. The 1935 post office, designed by C.C. Hook and W.W. Hook, features marble wainscoting and a mural commissioned by the WPA. The 1935 post office still stands on its original brick foundation and is part of the *Architectural Heritage Driving Tour* available to visitors at Gaston County Library branches. (Courtesy of the City of Gastonia Downtown Development.)

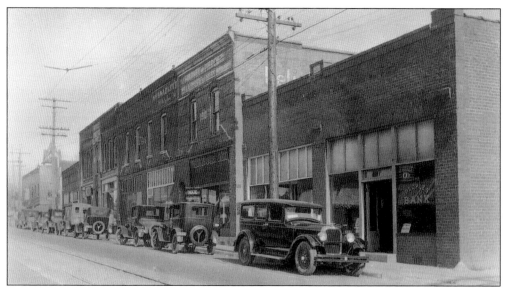

According to the U.S. Census of 1930, Gaston County's population totaled 78,093. Many folks were out of work, but the strike at Loray Mill had so consumed the public that events leading up to the Great Depression went virtually unnoticed until the banks closed. People's Bank of Gastonia liquidated. The bank was part of a shopping district known as Loray Square, or Greasy Corner. This photo was taken c. 1926. (Courtesy of the N.C. Division of Archives and History.)

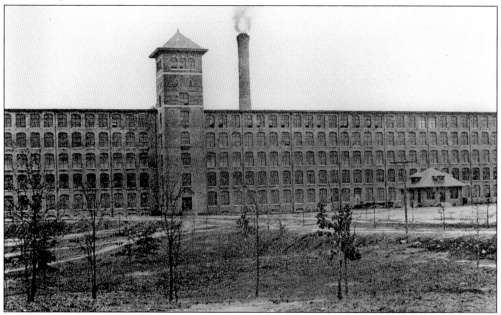

Loray dwarfs its mill office in this view of the newly completed textile plant. Along with county investors, George W. Gray established Trenton, Ozark, Flint, Gastonia Cotton Manufacturing Company, Avon, and Loray mills at the dawn of the 20th century. Gray was well liked by his workers, so the sellout of Loray to another company disheartened the more than 1,800 employees. Today, many of the structures financed by Gray still stand and provide manufacturing facilities within Gastonia's city limits. (Courtesy of Haithcox Photograph, public domain.)

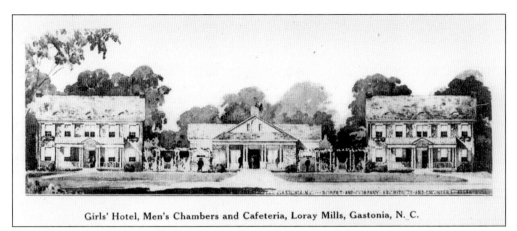

Girls' Hotel, Men's Chambers and Cafeteria, Loray Mills, Gastonia, N. C.

Manville-Jenckes Loray Mills began manufacturing tire cord fabric to serve the automotive industry. Employee pay and benefits remained good. Separate dorms for single women and men working at Loray featured a cafeteria, laundromat, bowling alley, poolroom, and modern shower baths. Manville-Jenckes Loray Mill even provided day care for infants of working moms, but increasingly, Loray's employees suffered in the face of criticisms and exaggerations about poor labor conditions within the paternal mill village systems of the South. This 1900s drawing was made by Robert & Company Architects and Engineers of Atlanta, Georgia. (Courtesy of the N.C. Division of Archives and History.)

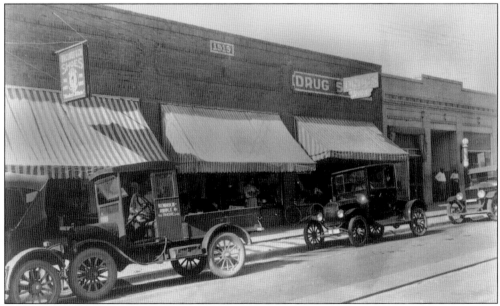

At the time this photo was made in 1926, life around Loray Mill was good. In 1993, Firestone Fibers & Textiles moved out of Loray Mill to a new $20-million plant in western Gaston County. Firestone donated Loray to Preservation North Carolina. As the popularity of loft apartments increases in the South, Loray Mill, located on Second Avenue in Gastonia, may be redesigned to suit residential needs. The mill can hold a conference center, apartments, offices, stores, galleries, and studios. Loray Mill, a city landmark since 1900, is featured in *Saving America's Treasures*, a book produced in 2001 by National Geographic, National Trust for Historic Preservation, the National Park Service, and the White House Millennium Council. (Courtesy of the N.C. Division of Archives and History.)

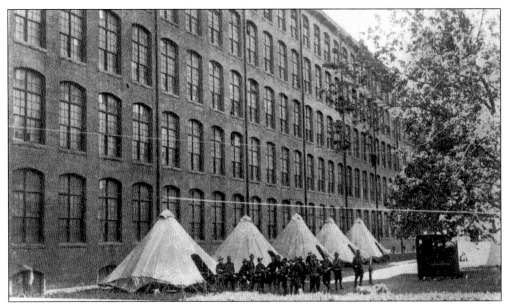

Communists sent Fred Beal, a Massachusetts mill worker, and George Pershing, a writer for *Daily Worker*, a Communist newspaper, to organize a Gastonia branch of the National Textile Workers Union in January 1929. Loray supervisors planted spies inside the factory, and five men were dismissed as troublemakers on March 25. Angry, Loray employees abandoned the looms on April 1. The action made national newspaper headlines, and tensions mounted. The strike lasted about two weeks. (Courtesy of the N.C. Division of Archives and History.)

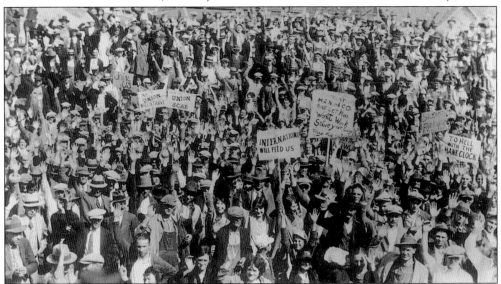

People picketed, and Mayor W.T. Rankin solicited Gov. O. Max Gardner for help. The National Guard out of Shelby responded on April 3. Troopers pitched their tents at Loray Mill and arrested lawbreakers. By April 12, the strike was two weeks old. Encouraged by the approximately 1,000 strikers at Loray, Beal tried organizing mill workers in Bessemer City and High Shoals, but the villagers rejected the union. In 1934, the union tried again to organize workers throughout Gaston County and failed. (Courtesy of Haithcox Photograph, public domain.)

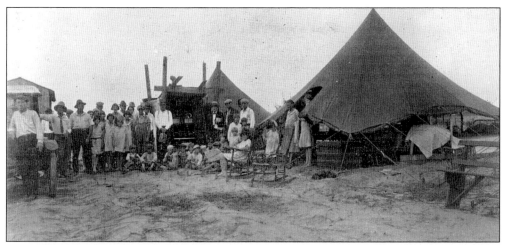

The strike at Loray Mill grabbed the attention of writers, poets, and lyricists. Authors including Theodore Dreiser, Sinclair Lewis, Sherwood Anderson, and LeGette Blythe wrote about the turmoil for national and international magazines. Eight novels and several plays were inspired by the strife of strikers who were evicted from their mill homes and moved into tent colonies. They were chastised or physically attacked by non-strikers. In June 1929, Police Chief O.F. Aderholt and several of his officers investigated a disturbance at one of the tent colonies. After the gun smoke cleared, Aderholt was dead. The tent colony residents suffered through more violence including arson. (Courtesy of the N.C. Division of Archives and History.)

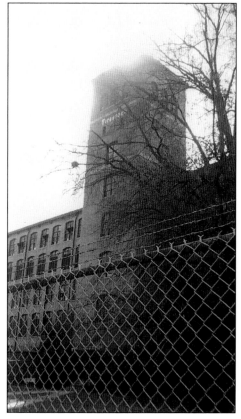

Authorized capital for Manville-Jenckes Loray/High Shoals factories grew from approximately $28.3 million to $39 million. In a 1926 *Gaston Gazette* article, Manville-Jenckes Loray reportedly strived to appease its workforce by donating funds to several local schools. Unfortunately, the Great Depression approached and profits diminished. Workers complained about long hours and mediocre wages. Worse, Loray's new owners committed a cultural faux pas. Unlike Northern structures, textile factories in the South, especially in Gaston County, existed in open fields. Manville-Jenckes surrounded Loray with a tall fence as customary in the North. Outraged employees called Loray a prison and some even quit their jobs. When word about the tensions at Loray reached New York City, the headquarters of the American Communist Party, Northern activists prepared pamphlets touting the National Textile Workers Union. Activists then headed south with plans to denounce the mill's management methods. (Photo by P.E. Peters.)

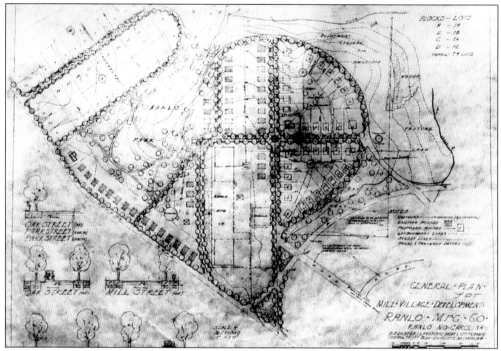

Before real estate developers plowed over fields and forests, textile mills hired architects, or city planners, to create entire towns complete with green spaces. An example is Ranlo. Investors John C. Rankin and W.T. Love approved the general plans for their namesake about 1916. By the 1930s, Ranlo Manufacturing operated with 21,726 spindles and 80 looms. Ranlo incorporated as a town in 1963. This rendering was created by B.S. Draper of Charlotte. (Courtesy of the N.C. Collection, University of North Carolina Library at Chapel Hill.)

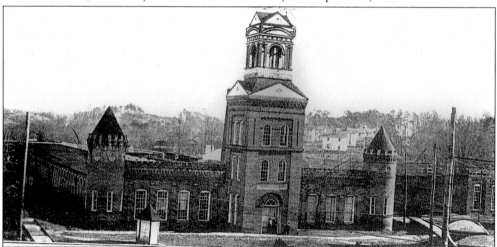

McAden Mill No. 2 remains one of Gaston County's finer architectural features. The left turret is still visible from Main Street in McAdenville, but the Romanesque bell tower diminished in size due to inclement weather. In 1956, McAdenville became nationally known as Christmas Town, USA. According to 1980 automatic street counters, more than a million and a quarter people viewed the town's Christmas light display, but the rolling hillsides, duck ponds, and quaint homes are just as charming during daily visits. (Courtesy of *Southern Textile Bulletin*.)

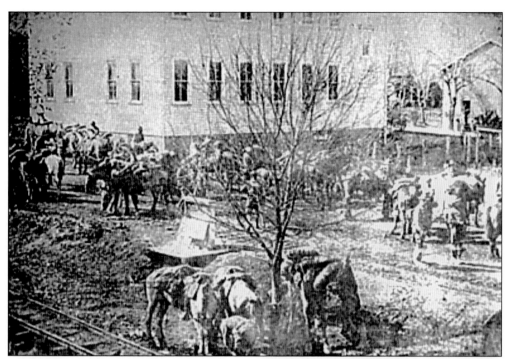

World War I soldiers were photographed behind the R.Y. McAden Memorial Library in McAdenville. The men and their horses rest next to the railroad tracks. A mule pulled the rail cart that ran on the tracks back and forth from the mill. Today, this track area is a paved road.

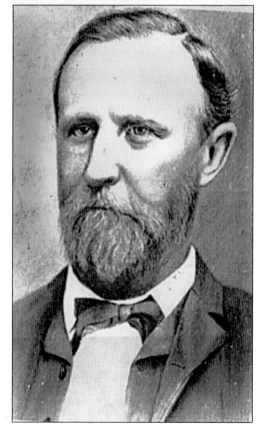

McAdenville, or Henderson Shoals, belonged to James Henderson, a gristmill operator. His friend Adam Alexander Springs (1776–1840) acquired the shoals prior to the existence of any village. Pictured here, Rufus Yancey McAden (1832–1889) of Charlotte, North Carolina bought the property about 40 years later from W.A. Stowe and Jasper Stowe. In 1881, McAden and his four sons organized Spring Shoals Manufacturing Company. Benjamin (1859–1888), George (1862–1890), and Giles (1867–1905) held various offices within the mill. In 1883, Spring Shoals Manufacturing changed its name, and in 1904, Henry McAden (1872–1957) became president of McAden Mills. (Courtesy of *Southern Textile Bulletin*.)

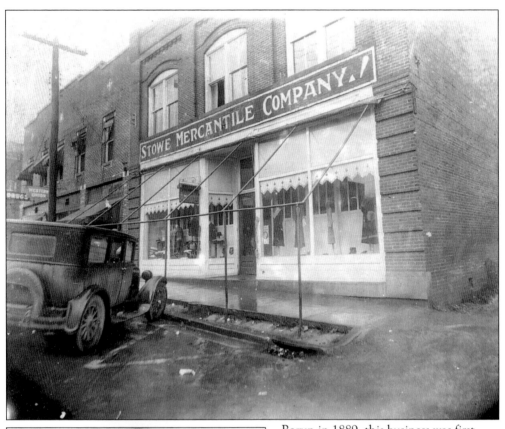

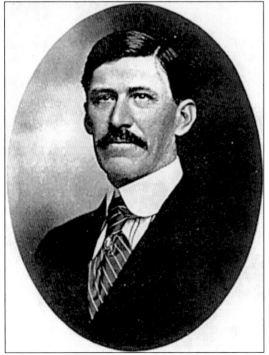

Begun in 1889, this business was first known as Stowe and Puett Store, later Stowe Brothers, and then Stowe Mercantile. Currently, the mercantile next to the Belmont depot is vacant of business activities. (Courtesy of the N.C. Division of Archives and History.)

Born in a log cabin, Robert Lee Stowe (1866–1963), son of Charles T. Stowe (1833–1907) and Margaret Ann Sloan, has enjoyed buildings, roads, bridges, and mills named for him. R.L. Stowe, seen here c. 1922, developed Chronicle Mills, Majestic Manufacturing, and others. With the help of his son Daniel, R.L. Stowe reactivated McAdenville Mill in 1939. He organized the Bank of Belmont and later served on the Gaston County Board of Commissioners for 41 years. (From the 1922 *Clarion* yearbook, Belmont.)

In the foreground of this postcard image are the railroad tracks. In the background is the Stowe mill office, a prominent fixture to Belmont's Main Street in 1923. Main Street physically narrowed between 1996 and 1998. Sidewalks expanded beside renovated brick structures, creating a safer environment for pedestrians and shoppers. (Courtesy of the N.C. Division of Archives and History.)

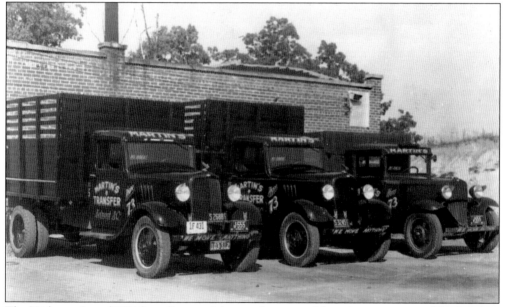

The Highway Act of 1921 literally paved the way for successful trucking companies like Carolina Freight Carriers Corporation of Cherryville and Martin's Transfer Trucks of Belmont, whose vehicles are seen here c. 1935. New and improved roads, including 3,636 miles of hard-surface roads, reached all 100 counties. By 1930, a gallon of gas was 10¢, down from 18¢ a year earlier. The state highway speed limit was 45 miles per hour. Transportation improvements created the automobile-oriented suburbs, and soon middle-class neighborhoods developed with houses featuring garages. (Courtesy of the N.C. Division of Archives and History.)

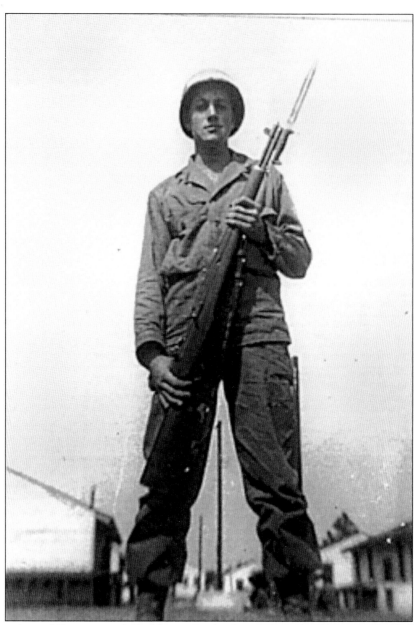

Small numbers of Gaston men drilled for warfare by the summer of 1941, training with Canadian and British forces until the U.S. Army began mass mobilization of U.S. troops to the Asian and European theaters. Gaston's first draftees into military service left home in October 1940, but even a year earlier Gaston mills felt the war's impact. Production orders increased. Wages climbed as mills obtained government contracts to supply the military with fabric for uniforms, upholstery, and other items. Caravans of jeeps, trucks, and tanks rumbled down Franklin Avenue while airplanes periodically soared overhead. Ration stamps became a way of life, and scrap metal, tire rubber, and papers were routinely collected throughout Gaston neighborhoods. Robert (Bob) Cicero Stewart shows off his bayonet in a snapshot he sent home to his mother in Gastonia. Bob would not be a casualty of World War II and still resides in Gastonia. (Courtesy of Jim Stewart.)

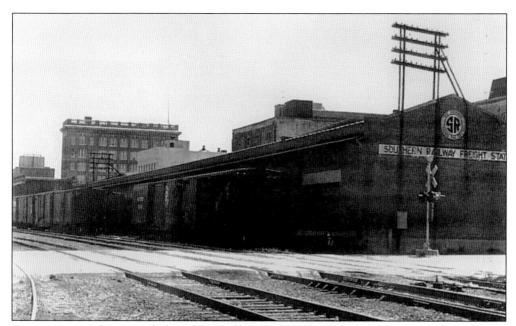

Gastonia's train depots, including this Southern Railway Freight Station, proved vital in moving supplies and people through the Carolinas at the time of World War II. Service men usually would greet their families at the passenger depot, which stood before the Armington Hotel. (Courtesy of the City of Gastonia Downtown Development.).

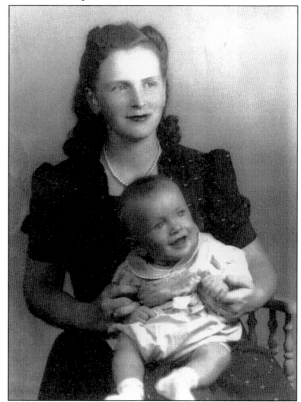

Campbell Lester Stewart (1918–1994) married Betty Marie Abbott and served in the World War II "Railsplitter" division, or the 771st Tank Division. He survived the Army's crossing the Rhine River into Germany to return home to his wife and infant son in Gastonia. Campbell became a general contractor in the county. His son, James C. Stewart, born in 1941, enjoyed working with his father and so decided to study architecture in the 1960s. In this vintage image, Betty Marie Abbott Stewart shows off little Jim. (Courtesy of Jim Stewart.)

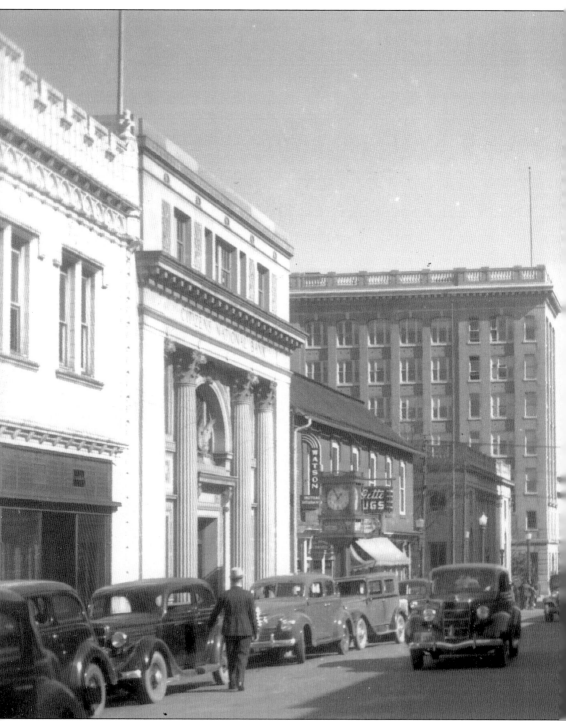

A solitary stoplight dangles like a jewel over the junction of South Street and crowded Main Avenue in Gastonia during the era of the World Wars. By the end of World War II, automobiles dominated the urban landscape. Complete lists of veterans from the War of Independence, the War between the States, and the Spanish-American War can be reviewed in the book *The*

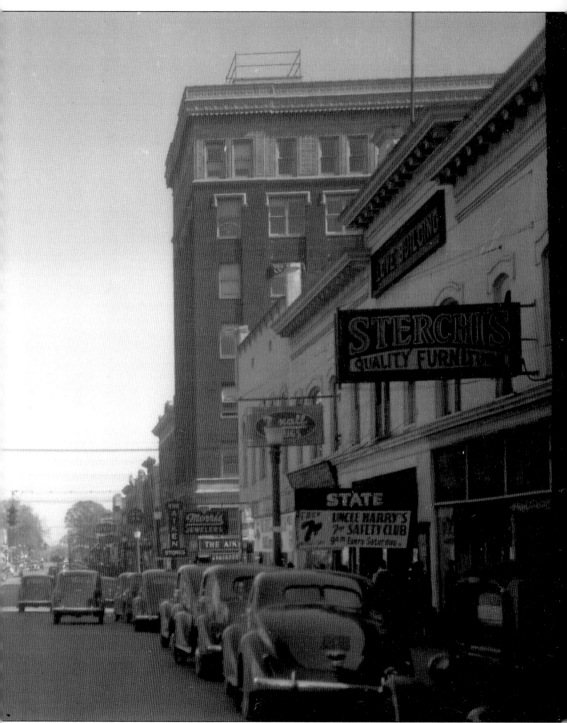

County of Gaston by Cope and Wellman. Across the area, World War veterans are remembered on granite or stone memorials within their hometowns. A complete list of veterans can also be found in the foyer of Gaston Memorial Hospital. (Courtesy of the N.C. Division of Archives and History.)

In 1925, Hugh White designed the 32 North Main Bank of Belmont building next to Belk's. Eight years after the bank's start up, the government reduced the workweek and increased the pay scale, but the effort failed to relieve the slumping economy in the textile industry. In 1934, textile unions again campaigned to unionize local firms, but again, workers across Gaston rejected them. Economic rebound hinged on programs sponsored by the WPA. By 1939 Belmont, and towns like it, boomed. State legislature officially changed the town's name to the City of Belmont in 1945. In 1957 Duke Power Company built Plant Allen, an electricity generation station utilizing coal for fuel. The plant provided new jobs, and Gaston's economy further diversified. (Courtesy of Haithcox Photography, public domain.)

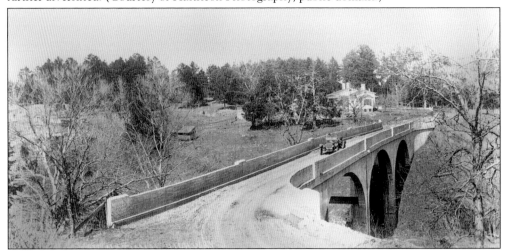

Built in 1911, the bridge at the site of Sloan's Ferry in Belmont vanished in torrential floods of 1916. It was rebuilt, and by the end of World War II, highway construction would progress to the point that affordable cars would replace mass transit systems such as trains, trolleys, and buses. For the first time, the middle class could drive to nearby Charlotte or other cities to look for work. People could even remain in their cars and watch a movie at the drive-in theater in Belmont that still stands and operates to sell out crowds. (Courtesy of the N.C. Division of Archives and History.)

Three

EDUCATION AND INSTITUTIONS

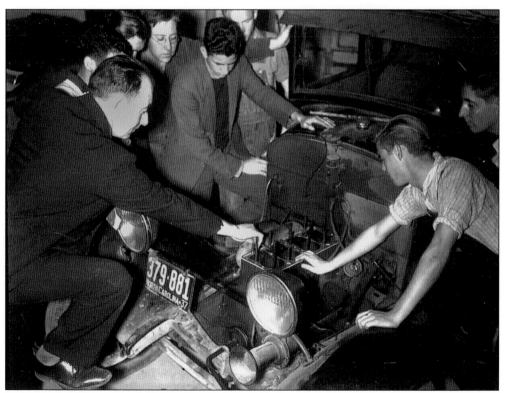

Cramerton Mills provided prosperity for the town's people. The town's schools expanded with additional programs such as shop classes in auto mechanics in 1937. (Courtesy of the N.C. Division of Archives and History.)

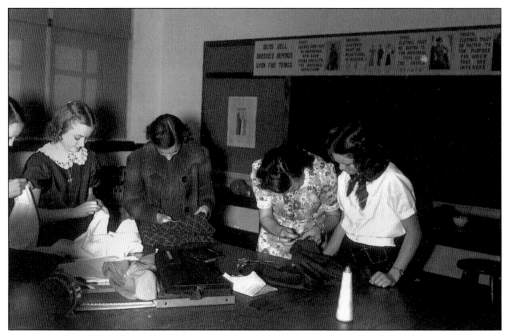

Local mills built and strongly supported some of the first schools. Constructed in 1920, Cramerton School, also known as the Mayworth School, on Eighth Avenue is one example. Co-ed from the beginning, Cramerton School's home economics class received fabrics from Cramerton Mills for sewing classes, pictured here in 1940. The brick Cramerton School was constructed for whites only, but a school on Washington Avenue served Cramerton's African-American population until the schools consolidated in 1968. (Courtesy of the N.C. Division of Archives and History.)

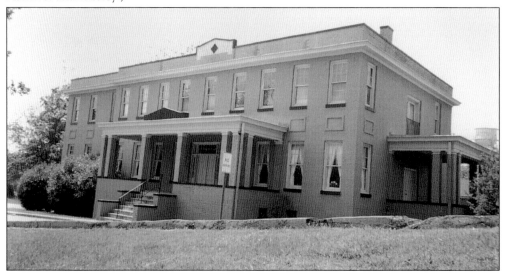

There are few teacherages left in Gaston County. This one in Lowell, located at the intersection of N.C. 7 and Teacherage Road, faces the railroad tracks as if anticipating new arrivals to get off the train. It was built in 1924 to house teachers when the local school was not in session. The town of Lowell utilized the structure for a community building until May 2001 when it was sold to the private sector for commercial development. (Photo by P.E. Peters.)

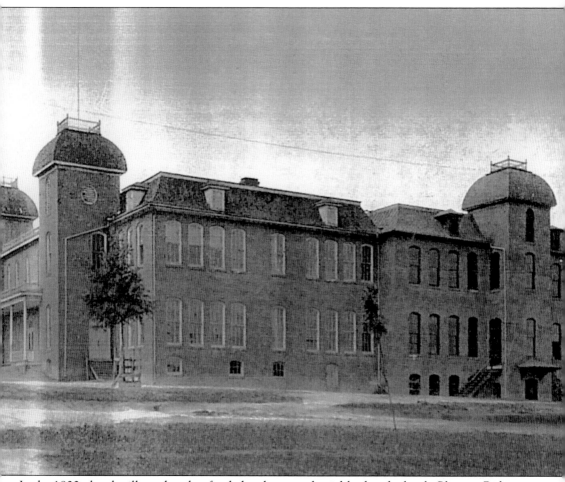

In the 1800s, local mills or churches funded and operated neighborhood schools. Pleasant Ridge AME Zion Church sponsored the first preparatory high school for African-American youths, and in 1895, its first graduating class totaled 18. Loray Graded School, established in 1912, served white children whose parents worked at Loray Mills. Gastonia Central Graded, pictured above, burned in 1913. About the same time, public schools were established and expanded through local taxes. In 1924 Gastonia High opened for whites. In 1968, schools racially integrated students and staff when Gastonia City Schools consolidated with Cherryville City Schools to form Gaston County Schools. Currently, Gaston County public school is the sixth largest school system in the state. The system offers 2 North Carolina Schools of Excellence, 7 Schools of Distinction, and 37 Exemplary Schools. (Courtesy of the City of Gastonia Downtown Development.)

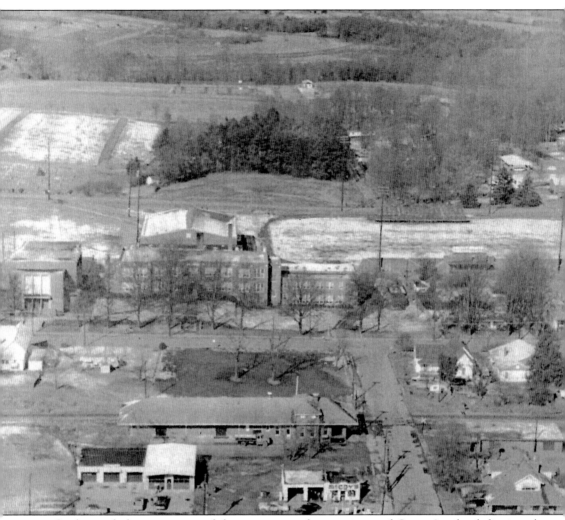

Quality and choice are two of the prominent characteristics of Gaston's school district, the sixth largest system in North Carolina. Today, there are 51 schools serving more than 30,000 students. More than one-third of Gaston's teaching force has a master's degree. In 1968 schools racially integrated students and staff when Gastonia City Schools consolidated with Cherryville City Schools to form Gaston County Schools. Highland High School also entered the mix. Comprised of African Americans, Highland High was the only Gaston County institute that obtained membership in the Southern Association of Colleges and Secondary Schools. From 1955 until 1965, the school maintained this distinction. Mrs. Daisy N. Erwin organized Gaston County's first Parent-Teacher Association, or PTA, at Highland High. Few vintage images exist of the school although currently there is a Highland School of Technology, a rigorous academic curriculum available to all students up to the challenge of a high-tech learning environment. Pictured is a 1960s aerial view of Cherryville High. Starnes Auditorium is on the left, and Nixon Gym and Rudisill Stadium is in the background.

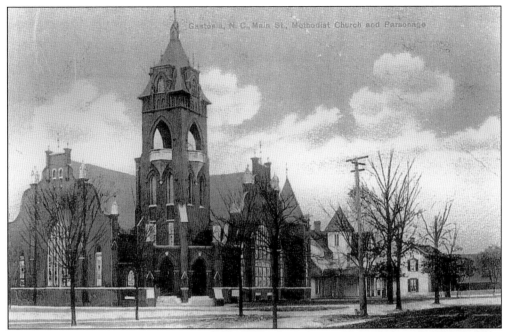

In this 1920s postcard image the Methodist church and its parsonage face Gastonia's Main Street. The church structure is long gone, but other denominations still serve the downtown dwellers with regular Sunday and Wednesday services. (Courtesy of the City of Gastonia Downtown Development.)

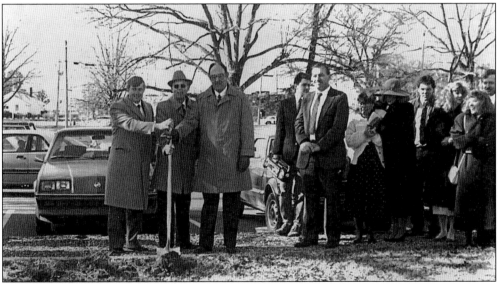

People watch the groundbreaking ceremony for the West Avenue Presbyterian church in Gastonia. The three men gripping the shovel, from left to right, are James (Jim) Campbell Stewart of Stewart·Cooper·Architects; Hugh Pursley, chairman of the "Venture in Faith" campaign; and Jim Ferguson, chairman of the building committee. Many Gaston church renovations, additions, and restorations are contributed to the design team at Stewart·Cooper. The local architects designed other structures including Gaston Public Library's Main Branch on Garrison Boulevard. (Courtesy of Jim Stewart.)

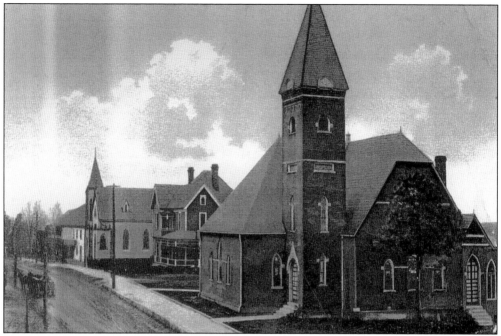

Gaston County had 10 mills and 60 churches in 1890; 27 mills and 78 churches in 1900; and 48 mills and 98 churches in 1910. By 1920 churches outnumbered the mills at 109 to 90. Pictured above is the First Baptist Church of Gastonia, organized about 1876. This sanctuary ,constructed about 1885, stood on the corner of Marietta and Long Street. (Courtesy of the City of Gastonia Downtown Development.)

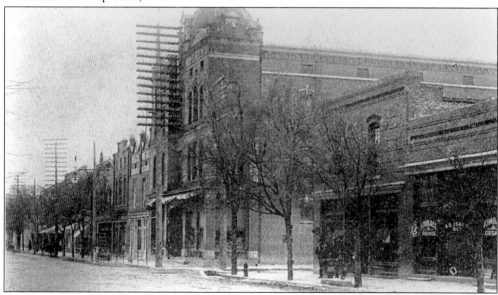

Despite its Romanesque tower, this building is not a religious center but a carriage and harness manufacturing facility known as Craig and Wilson Retail and Wholesale in Gastonia. According to author and historian Kim Withers Brengle, none of Gaston's 18th-century churches survived, though many of the congregations thrive. Churches have been relocated and rebuilt, but this building is a memory. (Courtesy of Haithcox Photography, public domain.)

First Baptist Church on 201 West Franklin Boulevard is the 1918 creation of Charlotte architect Willard G. Rogers. The architectural style is Mission, and green tiles crown the church. An octagonal lantern atop the square bell tower soars high over the city of Gastonia. First Baptist is now referred to as Unity Place, the home of St. Stephen's AME Zion Church and the Gaston County Arts Community. (Photo by P.E. Peters.)

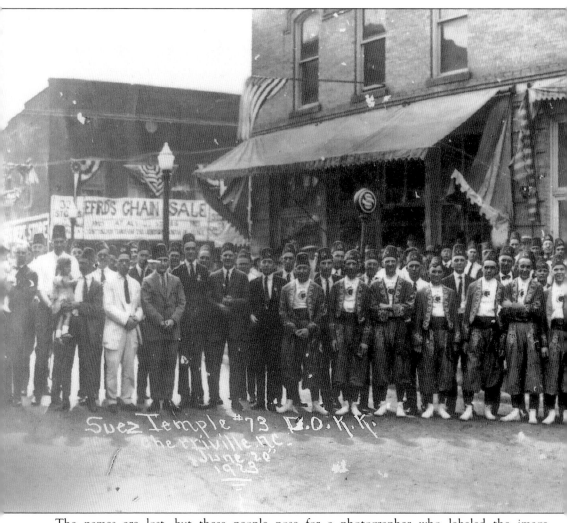

The names are lost, but these people pose for a photographer who labeled the image "Suez Temple #73, Cherryville, N.C., June 20, 1923." The store in the background is Hendricks-

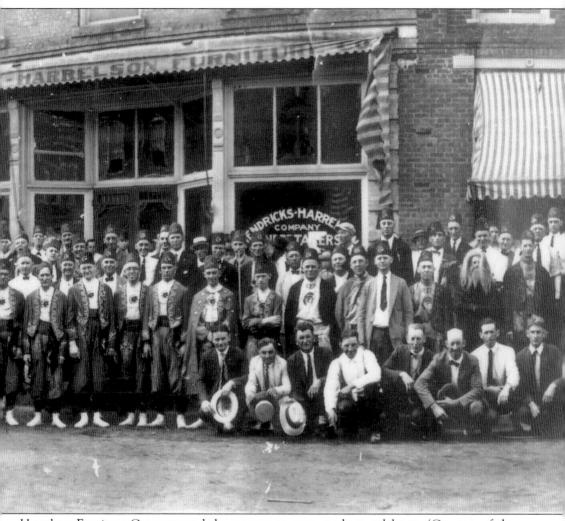

Harrelson Furniture Company and the townsmen seem ready to celebrate. (Courtesy of the N.C. Division of Archives and History.)

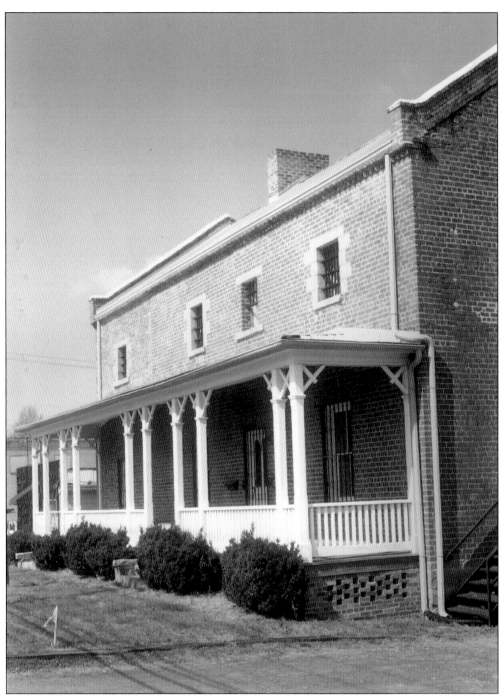

Located on 108 East Trade Street in Dallas, this early Piedmont penitentiary still stands on its original foundation. Beginning in 1848, this building, with its handcrafted porch, served as county jail until the county seat moved to Gastonia. The first floor operated as living quarters for the sheriff and his family. Prisoners were locked up on the second floor that still contains the main cellblock. During the latter half of the 20th century, the facility operated as the Old Dallas Jail Restaurant. (Photo by Richard L. Aheron.)

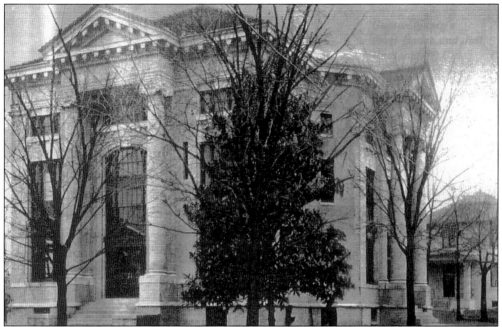

This postcard offers a glimpse of the original layout of the Gaston government complex designed by Frank Milburn of the Washington, D.C. firm Milburn & Heister. The 1911 county jail is detached and behind the courthouse. Both structures on 151 South Street featured Milburn's tan bricks. Defendants involved in the strikes of 1929 and the associated murders were tried in Mecklenburg. (Courtesy of the City of Gastonia Downtown Development.)

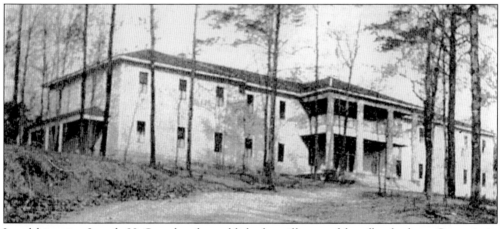

Local historian Joseph H. Separk, who published an illustrated handbook about Gastonia in 1906, states that as educational needs increased, churches established academies and schools. The Methodist Episcopal Church South organized Oakland High. The first preparatory high school for African Americans was organized at Pleasant Ridge AME Zion Church, and its first graduation dates to 1895. By 1920, schools sponsored by churches and industrial groups were consolidated and organized and supported by local taxes. An upsurge of financial support resulted in physical growth as well as instructional programs. The Depression retarded the advancements, but schools rebounded during the 1940s and have progressed ever since. Pictured is a dormitory for Linwood College. The school, located at the base of Crowders Mountain, closed in 1921 as academies multiplied throughout the region.

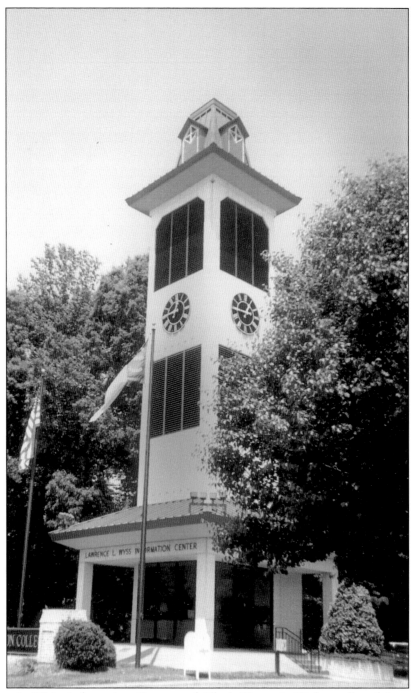

Lawrence L. Weiss Information Center and Clock Tower is 80 feet tall and features bells reminiscent of its predecessor affixed to the first Gaston College (1886–1905). In 1965 Gaston College, chartered in 1963, merged with the thriving Gaston Technical Institute, established in 1952. The following year the School of Nursing founded by Gaston Memorial integrated with Gaston College, situated on 200 acres between Gastonia and Lincolnton and less than 25 miles from Charlotte. (Photo by P.E. Peters; courtesy of Gaston College.)

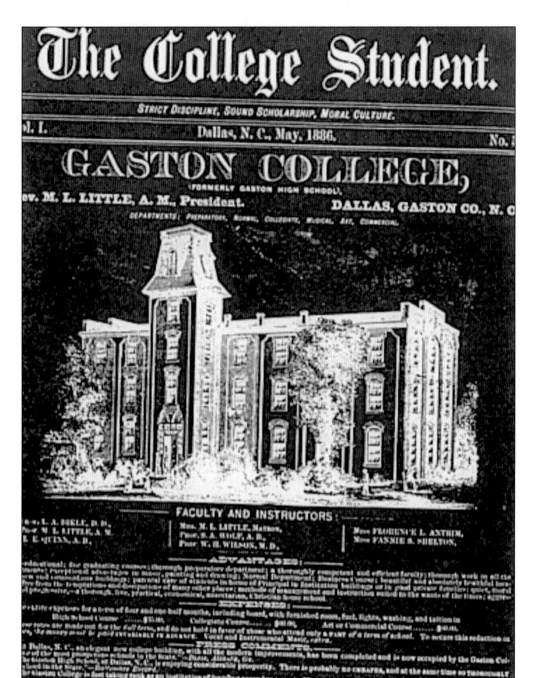

Other than its name, Gaston College, located next to Highway 321 in Dallas, has no direct connection with this 1886 facility also known as Gaston High School. The brick school replaced an 1870s log structure once the home of Gaston Academy. Gaston High, privately funded in part by area Lutheran churches, offered co-ed classes under the direction of Rev. Marcus Lafayette Little. In 1886, the school reorganized its educational programs to become Gaston College. Five years later Little died in a train wreck near Newton, North Carolina. Enrollment gradually declined until Gaston College closed its doors in 1905. The 1886 building on South College Street in Dallas was eventually demolished. (Courtesy of Gaston College.)

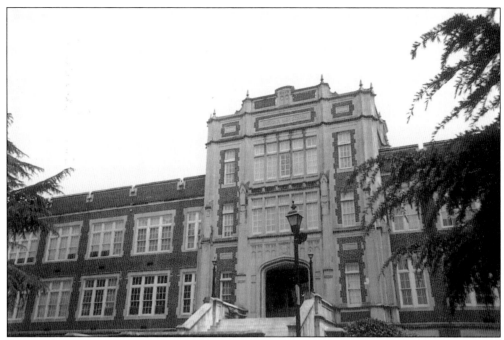

Hugh White designed an exceptional piece of collegiate Gothic architecture, which included a swimming pool and a $14,000 pipe organ. The school opened in 1924 with a white student body of 400 and an auditorium that could seat 1,600. Due to the leadership of Frank L.Ashley, the principal by 1929, Gastonia High became the envy of towns statewide. By 1970 the integrated school became a junior high, and a new institute, Ashbrook High, opened on New Hope Road. Gastonia High structure is presently known as Ashley Arms, a luxury apartment complex dominating the quaint neighborhoods surrounding Garrison Boulevard and 800 South York Street. A few blocks to the west stands Loray, where similar space conversion plans will be implemented to preserve the majestic structure. (Photo by P.E. Peters.)

A valley view of a soccer team at Bessemer City Middle School captures the mountain peaks, which separate Bessemer City from Gastonia. In 1968 Gastonia City Schools consolidated and integrated in association with Cherryville City Schools. The newly formed school system became Gaston County Schools. Two new high schools were constructed in 1968, Hunter Huss and Ashbrook. Gastonia has two private schools (grades K–9) that began operations during the 1940s. (Photo by P.E. Peters.)

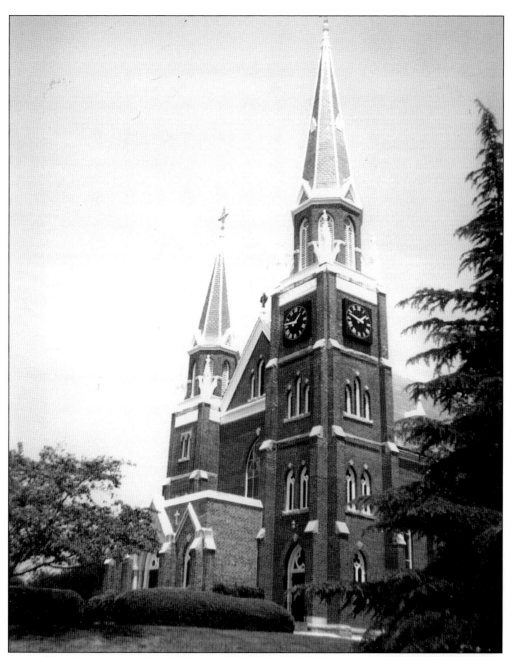

A wooden structure erected in 1887 served as Belmont Abbey's first chapel. It no longer stands. Abbey Baslica of Mary Help of Christians, in built 1892–1893 and designed by Peter Dederichs in the German Gothic Revival style, held cathedral rank from 1910 to 1977. As early as the 1870s, African Americans were invited to mingle with whites and participate at the abbey's liturgies. In 1964–1965 the interior was completely renovated by Friedrich H. Schmitt. The structure was elevated in rank to Minor Basilica in 1998. The Basilica has been on the National Register of Historic Places since 1973. The campus is now a part of the Belmont Abbey Historic District and it, too, is on the National Register of Historic Places. (Photo by P.E. Peters; courtesy of Belmont Abbey College.)

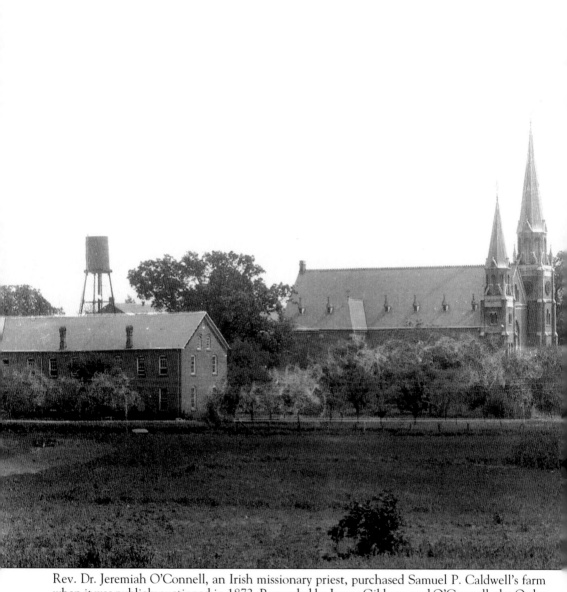

Rev. Dr. Jeremiah O'Connell, an Irish missionary priest, purchased Samuel P. Caldwell's farm when it was publicly auctioned in 1872. Persuaded by James Gibbons and O'Connell, the Order of St. Benedict in Pennsylvania agreed to establish a boy's college named Maryhelp on the site. In 1885 the first monk elected abbot of North Carolina declined the office. Leo Haid, a 36-year-old monk and teacher from Pennsylvania, took the less-than-grand post. Haid's confidence came from Providence alone. Soon Haid had success at the struggling Catholic school. In the spring of 1886, Haid called a town meeting. He wanted to change the town's name since Catholics

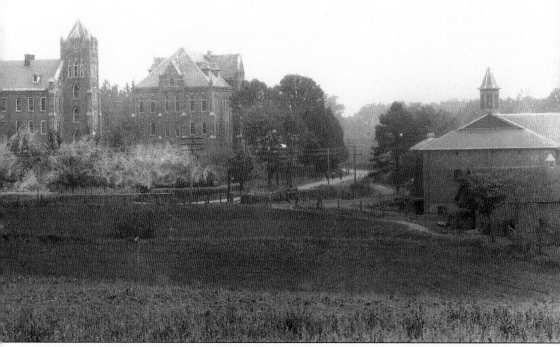

detested Giuseppe Garibaldi, an Italian rebel who fought to pry Rome from papal control. Since Protestant locals were not particularly fond of the name Garibaldi, they approved Haid's second suggestion "Belmont," a Latin term for "beautiful mountain." Haid's first suggestion was to call Belmont the Town of Maryhelp. Pictured is the college in the days when its dairy (at the right in this c. 1907 view) provided milk for the region. The dairy is gone, but Belmont Abbey continues to bottle and market its spring water. (Courtesy of the N.C. Collection, University of North Carolina Library at Chapel Hill.)

Although the 1894 building no longer stands, St. Benedict School operated by the Sisters of Mercy and Fr. Melchior Reichert, O.S.B., served as an elementary school for African Americans routinely restricted from whites-only academies. The Abbey encouraged its white students and teachers to assist with the upkeep of it, and oral tradition maintains that local residents frequently resented the Abbey's intermingling of the races. Pictured is the Stowe Building and St. Leo Hall, built 1906–1907. Celebrity visitors to the college include former president Gerald R. Ford, astrophysicist Wernher Von Braun, baseball great George H. "Babe" Ruth, evangelist Billy Graham, journalist Charles Kuralt, and actor Danny Thomas, just to name a few. (Photo by P.E. Peters.)

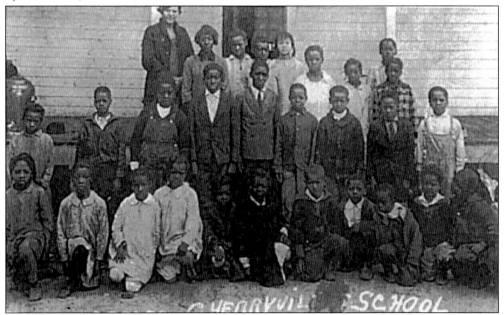

Cherryville School third graders pose for this rare vintage image during the late 1920s. African-American education facilities ranged from good condition, as in the case of the Abbey's academy, to poor. Rural environments seemed to lack the best in provisions and facilities for the children. (Courtesy of Gaston Schools.)

In 1876 Benedictine monks traveled from St. Vincent Abbey in Pennsylvania to begin St. Mary's College, also referenced as Maryhelp in documents. In 1890 the seminary opened. The College Building, erected in sections, would be constructed in 1886, 1888, 1898, and reconstructed after a 1900 fire. In 1983, the Administration Building, also known as the College Building, was renamed for industrialist Robert L. Stowe (1866–1963). Wheeler Athletic Center (built 1969–1970) is named for Howard A. "Humpy" Wheeler Sr., the first layman to hold an appointment among Abbey faculty. Humpy was a coach and teacher and the father of H.A. Wheeler Jr. of motor sports fame. These gestures by the college underscore the Abbey's close ties and commitment to serving the local communities throughout Gaston County and the region. (Photo by P.E. Peters.)

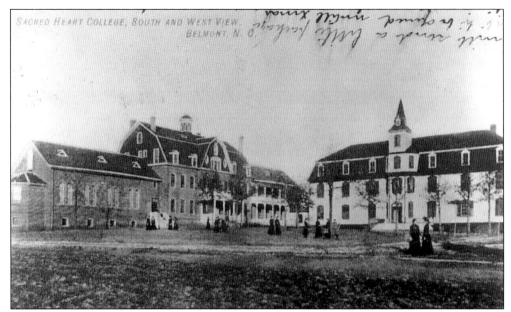

With the support of the Benedictines and the encouragement of Bishop Leo Haid, Sisters of Mercy of the Americas established a finishing school for girls at 414 North Main in Belmont in 1892. The school became Sacred Heart Academy in 1904. It was a junior college (1935–1965) and later a senior college (1965–1987). The school consolidated with Belmont Abbey in 1987. Campus buildings currently serve the Sisters by housing offices and rooms for the benefit of Holy Angels, a life support center for handicapped children, House of Mercy for indigents and the terminally ill, and Catherine's House, a support program for homeless women and children. In addition, Sisters of Mercy staff elementary schools and hospitals as well as parishes, dioceses, and colleges overseas. Pictured is Sacred Heart during the 1930s. (Courtesy of Haithcox Photography, public domain.)

Kathryne and Juanita Kennedy sit with Madeline Rose behind the Belmont Hotel in the 1920s. Mary Ethel Teague Kennedy, mother of Kathryne and Juanita, ran the place at times, and she enjoyed photographing the children of Belmont. (Courtesy of Juanita Kennedy Caldwell.)

While Gastonia's citizens organized the county library, Dr. George McAden, who died in 1905, financed the construction of the R.Y. McAden Memorial Library through provisions in his will. The memorial library, possibly the first in Gaston County, offered the McAden villagers a hall for recreation and community meetings. The structure operated as a library until the mid-1970s, and it remains on its original foundation at 27 Main Street, McAdenville. (Photo by P.E. Peters.)

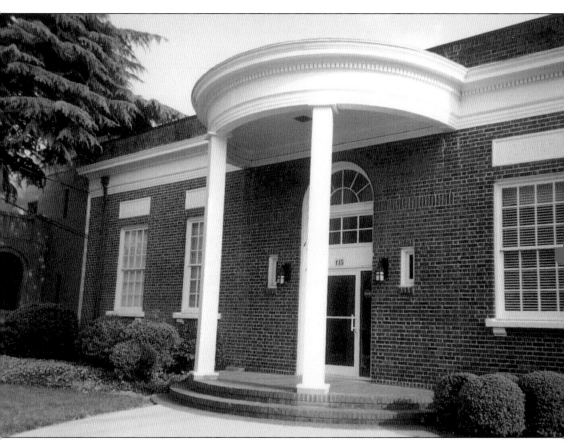

One of Gaston's first lending libraries existed in a trunk in Dr. D.E. McConnell's dental office. Loaded with books, the trunk periodically circulated from town to town. McConnell and nine community leaders, all men, formed Gastonia Public Library, a fee institute, which opened in 1905 on the second floor of the YMCA building at the corner of Main and South. The library closed in 1911 but reopened with public funding in 1917. In 1931, the free library opened in this $25,000 structure at 115 West Second Avenue in Gastonia. Designed by Hugh White and remodeled in 1958, the space contained shelves for 30,000 books, a children's reading area, two offices, an assembly room, and a mezzanine floor available for the county's art exhibitions. In 1937, the name was changed to Gaston County Library, but the facility ceased operating as a public library in 1976. The names of noted authors, however, can still be viewed on the tablets above the exterior windows. (Photo by P.E. Peters.)

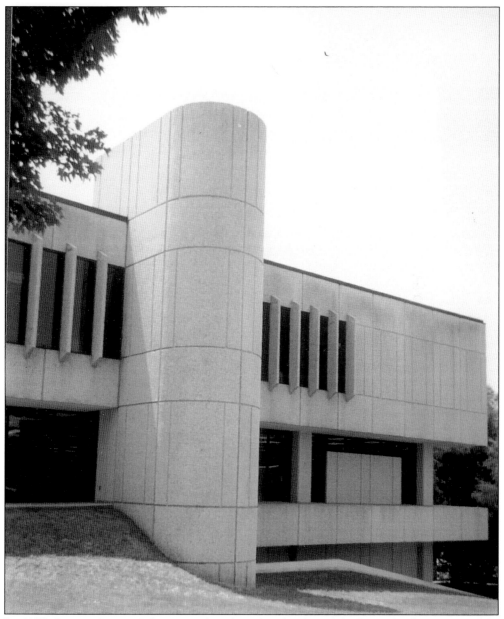

In 1937 Gaston County Library purchased its first book mobile for under $8,000. Quickly, the focus of the Friends of the Library shifted from local to regional service. In 1957 county commissioners elected to spend $250,000 for branch libraries in Belmont, Bessemer City, Cherryville, Dallas, and Mount Holly, and these branches opened between 1959 and 1960. In 1964 Gaston and Lincoln Counties formed the Gaston-Lincoln Regional Library with its headquarters in Gastonia. The co-op program secured grants and resources for the entire region, but the Hugh White structure could no longer contain the growing library. About 1978, this three-story, 60,000-square-foot facility, designed by local architects John Cooper and Jim Stewart of Stewart·Cooper·Newell, opened at the corner of Garrison Boulevard and Churchill Drive. The building continues to function as the Main Branch of the Gaston County Library System. (Photo by P.E. Peters.)

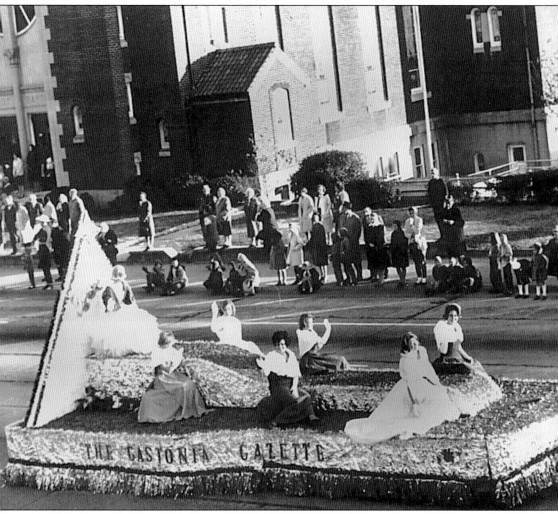

The *Gaston Gazette* provides more than daily news to the community. It sponsors Empty Stocking Fund for the benefit of the needy and the Starving Artist Festival for the talented but hungry. It also supports the Just Plain Dog Show because county hounds need a bit of applause now and then. Pictured is a crowd watching a mid-20th-century float cruise down West Franklin Boulevard. Unity Place, or the First Baptist church, is in the background. Children at the far right enjoy the glitter and glitz, and among them is a young Dereama Harris, a special events coordinator for the city. Other newspapers serving the area include *Belmont Banner* and the *Bessemer City Record*. (Courtesy of the City of Gastonia Downtown Development, Inc.)

Four

PEOPLE AND PLACES

In the middle of the 20th century, mill villages remained far from one another despite improved transportation. Cars were expensive, a luxury. A few homes had "party line" phones, and people walked dirt paths to get to the main roads or the whistlestops. As for entertainment, men congregated at the mercantiles or the railroad depots to gab. Some lucky families had a radio, but even fewer owned a television set. People read books and magazines made of paper for information, instead of staring at a computer screen. Live performances like operas were available in the "big city" of Gastonia, yet a few towns had cinemas. A drive-in theater, one of a dozen remaining in the Southeast, still stands and operates in Belmont, but for the most part, the mills, churches, or schools sponsored public entertainment in the form of sports tournaments and talent shows. (Courtesy of the N.C. Division of Archives and History.)

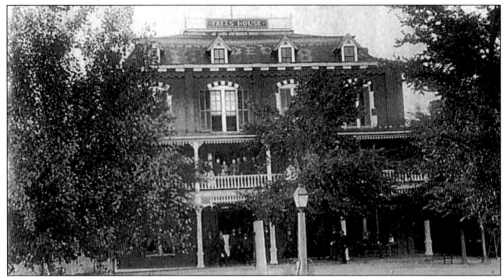

Armington Hotel, built in 1914, stood on a city block opposite the Southern Railway passenger station and railroad track. Prior to the Armington, the Falls House stood in the same block and was a popular gathering spot for large crowds awaiting trains during the 19th century. The 1998 county courthouse complex now stands on the land where Falls House stood. (Courtesy of L.A. Gardner.)

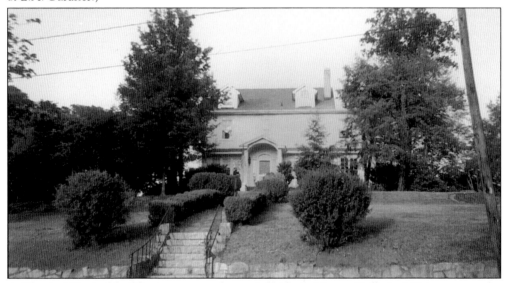

A Classical Revival building constructed on a hillside in Mount Holly in 1914 serves as the Robin's Nest Bed and Breakfast. Originally known as the Henry Rhyne house, Robin's Nest is located at 156 North Main. It offers antique furnishings in charming spaces known as the Blue Jay Room, Cardinal Room, Bluebird Suite, and the Hummingbird Room. As space is increasingly a premium, families convert their vintage homes into businesses for the benefit of preservation. Homeleigh Bed and Breakfast in Belmont is another example. The mansion quartered industrialist Abel Caleb Lineberger Sr. and his family in the 1920s. Lineberger was persuaded to leave Mount Holly and reside in Belmont by his friend and partner R.L. Stowe. Lineberger's mansion was sold in the 1990s and serves as a private residence as well as a hospitality establishment. (Photo by P.E. Peters.)

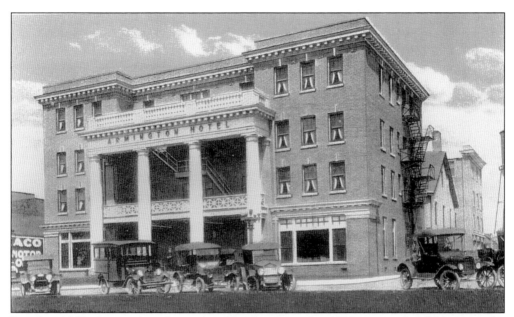

Razed in 1959, the majestic Armington Hotel, seen in this 1920s postcard, fell victim to the advent of motels and the arrival of a Holiday Inn in Gastonia. The 1998 county courthouse complex now stands on land where C.B. Armstrong and R.B. Babington constructed the luxurious hotel named for them. (Courtesy of the City of Gastonia Downtown Development.)

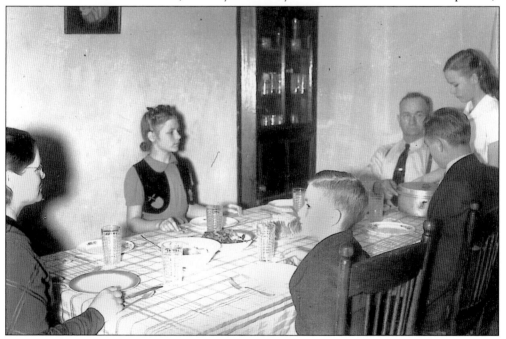

In November 1938, the Reese family sat down together for a meal in their Cramerton mill house. At the time, few food franchises like Burger King existed, but villages did offer good eateries or cafés. Ruby Keeter Café served Cramerton. Others like the Dallas Grill, which has operated since the late 1940s, are still open for business. (Courtesy of the N.C. Division of Archives and History.)

Kathryne Kennedy sits with Madeline Rose in a field near their hometown of Belmont, c. 1923. Squeezed between two rivers, the Catawba and the South Fork, Belmont now has a population of approximately 9,000 people. (Courtesy of Juanita Kennedy Caldwell.)

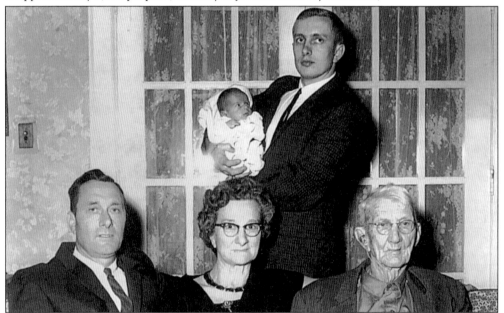

Newcomers to the area find that Gaston County folks have roots buried deep within their community. Pictured are four generations of Stewarts; from left to right are Campbell L. Stewart, World War II veteran; his mother, Essie Mae Wells Stewart; and her father, John Cicero Wells. Standing is young architect James C. Stewart with his son Campbell born in 1963. (Courtesy of Jim Stewart.)

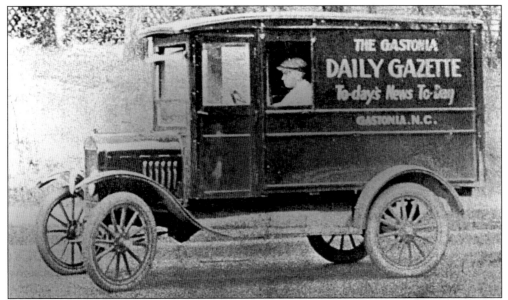

A year's subscription to the *Gastonia Gazette* cost $1.50 in 1880. In 1906, the newspaper, located at the corner of Main and South in Gastonia, became the property of the J.W. Atkins family, who ran the paper for 62 years until Freedom Communications purchased it in 1968. About 1919, the masthead changed to the *Daily Gazette* and its offices were on Airline Avenue across from the Southern Railway Depot. In the 1940s, the masthead again changed to *Gastonia Daily Gazette*. In 1962 a Sunday edition was added, and the offices relocated to the corner of Cox Road and Franklin in 1966. In April 2001, the *Gaston Gazette* again relocated to a complex at Northridge Shopping Center off Remount Road near I-85. Today, the *Gaston Gazette* prints the regional edition of the *New York Times* as well as local news.

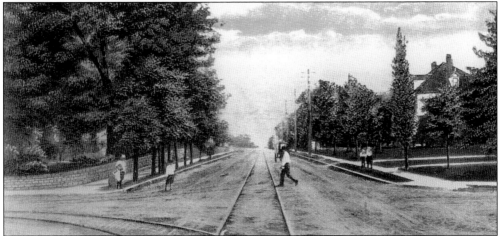

This postcard photographer faces east toward Charlotte, and at the left is a residential area that stood across from the 1911 courthouse in Gastonia. In the center of the image is West Franklin. At the right is another residential space that was redeveloped into a business district by the 1920s. This area of Gastonia is considered part of the 20-block stretch of West Franklin Boulevard slated for revitalization to begin in 2001. It contains many civic groups and historic structures including the city hall, the renovated Unity Place, several churches, the YMCA, and the chamber of commerce. (Courtesy of the City of Gastonia Downtown Development.)

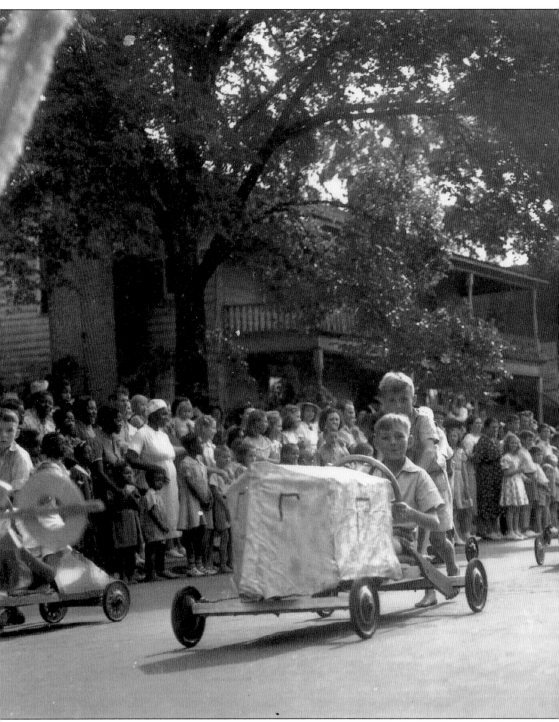

Few people thought about Europe and war during the 1939 Soapbox Car Race. Boys placed their vehicles at the top of the hill in Gastonia and rolled toward the residential area of West Main, which still stands. The race was a part of the annual Cotton Festival, now replaced with local celebrations like Garibaldi Fest in Belmont, Spring Fest in Mount Holly, Down Home Day

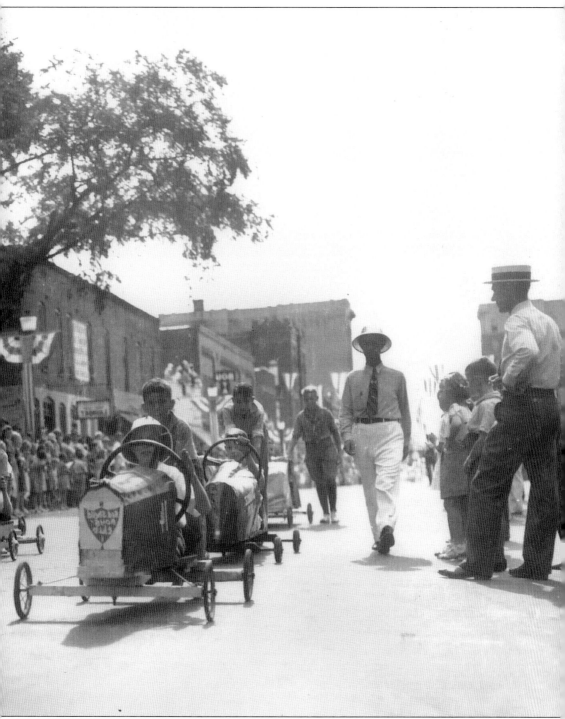

in Bessemer City, and Country Fest in Stanley. There are also year-round educational events sponsored by Gaston County Library, Schiele Museum, and Daniel Stowe Botanical Garden, just to name a few. (Courtesy of the N.C. Division of Archives and History.)

An educator and historian, Joseph Separk served as principal of Oakland High School, and he frequently wrote about Gastonia and Gaston County as early as 1906. In 1936, he penned the title *Gastonia and Gaston County: Past, Present and Future*. The vintage postcard above features a view of Gastonia's York Street looking north. Located 20 minutes from Charlotte and 20 minutes from the South Carolina stateline, Gastonia has preserved its neighborhoods while the county's population increases. Separk's first home is located at 316 South York Street. The Queen Anne home originally faced West Second Avenue, but Separk relocated it and built a second home on his Second Avenue property. Both homes still stand. (Courtesy of the City of Gastonia Downtown Development.)

Few visitors to Gastonia ever see the residential area of Main Street, which still stands southwest of the business district. Parts of Highland Avenue, Second Avenue, and Airline Road are also residential areas built in the early 1900s by various mills. These quality-made, affordable cottages are an alternative to the expensive subdivisions being constructed in a treeless countryside. Gradually, young couples and singles are buying these vintage houses. They renovate them in an effort to create a new kind of subdivision easily accessible to the I-85 corridor and the shops of Gastonia. (Courtesy of the City of Gastonia Downtown Development.)

John Biggers, an African-American artist and writer from Gaston County, has a master's degree from Pennsylvania State University and has participated in solo and group exhibitions throughout the world. His murals are featured in buildings from Houston to Chicago. His publications include *Ananse, The Web of Life in Africa*, and *Black Art in Houston: The Texas Southern University Experience*. Biggers has also illustrated books and poems including Maya Angelou's poem "Our Grandmothers." In cooperation with James Converse Biggers Jr., also a noted artist originally from Gaston County, John has created a number of Biggers Murals, which can be periodically viewed in tours and exhibits from North Carolina to Africa. (Courtesy of the *Gaston Gazette*.)

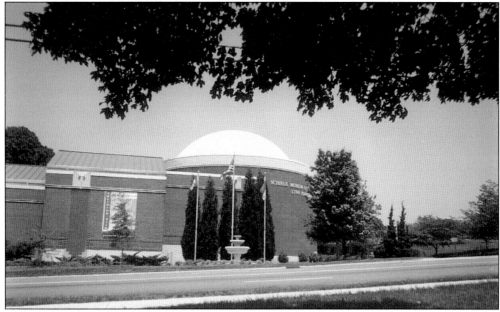

Born in Philadelphia in 1910, Rudolph "Bud" Melchoir Schiele worked as a ranger in the Great Smokey Mountains National Park and as an executive for the Boy Scouts. He and his wife, Lily, returned to Gastonia in 1961 and formed the Gaston County Museum of Natural History. The property site on Seventh Avenue, now Garrison Boulevard, was transferred to the City of Gastonia in 1964; it was renamed in honor of its founder. In 1967 a 30-foot dome planetarium was constructed. By 1991, a 30,000-square-foot addition provided more room for hands-on instruction and nature studies. The Schiele Museum of Natural History and Planetarium continues to feature an extensive array of wildlife and mineral collections. Cultural archaeology and anthropology are also a part of the museum's focus. (Photo by P.E. Peters.)

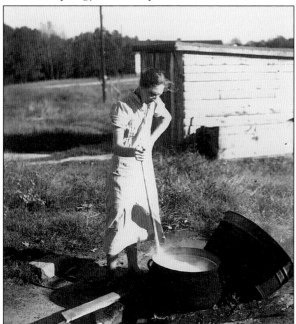

An unidentified Cramerton woman tints yarn the old-fashioned way in 1938. Periodically, the Schiele Museum of Natural History and Planetarium, located on Garrison Boulevard in Gastonia, offers similar demonstrations of antiquated textile techniques. Schiele Museum also offers a nature trail that takes visitors to a replica of an 18th-century Carolina Farm and a Catawba Indian village. (Courtesy of the N.C. Division of Archives and History.)

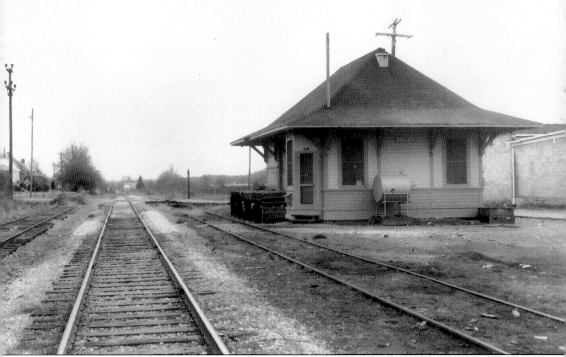

Six miles of wooden tracks were laid for mule-drawn ore carts at High Shoals to serve John Fulenwider's ironworks. Gaston's farmers quickly equated progress with railroads, and by 1860, narrow gauge and shortlines crisscrossed the county. Even during the Civil War, Seaboard Airline dared lay tracks in Cherryville. Three other shortlines operated within the county including Chester and Lenoir Railroad, Piedmont and Northern, and the Wilmington, Charlotte and Rutherford. The 1901 Dallas depot, first owned by Chester and Lenoir, was bequeathed to the county museum in 1976. Depicted here on its original foundation, the depot served the town on a site three blocks east of its present location at 215 West Main Street. The depot, a Carolina and Northwestern building, sits beside a 1940s caboose donated to the museum by Southern Railroad in 1977. (Courtesy of the N.C. Collection, University of North Carolina Library at Chapel Hill.)

A 1977 graduate of East Gaston High named William Richard Haithcox purchased his former employer's operations in 1987. Rick renamed Johnny Kanipe's business, and soon Haithcox Photography in Dallas served corporations across the Southeast. In February 2001, the Professional Photographers Association met in Raleigh to honor Rick as North Carolina Photographer of the Year. Rick has won numerous awards, and his creative images are regularly showcased in juried competitions and traveling exhibits sponsored by a variety of groups including the Light Factory and the South Carolina State Museum. Even ILFOPRO, a prestigious newsletter developed by Ilford Paper, has exhibited Rick's talents. Rick Haithcox continues to have an impact, both commercially and artistically, with his unique depictions of life within Gaston County and the United States. (Special thanks to Don McGinnis; courtesy of Haithcox Photography.)

Located on Lake Wylie and the Catawba Creek, Daniel Stowe Botanical Garden is the largest single donation of land and money in Gaston County history at approximately $27.8 million. Construction costs are predicted to inject more than $78 million into Gaston's economy as the garden nears completion in 20 years. Phase One of 110 acres, unveiled in 1995, opened to the public in 1999. Meticulous attention to the terrain produced the Amphitheater, Four Seasons Garden, Peroglas and Holly Walk, Cottage Garden, Canal Garden, and the Perennial Garden. The land also supports wildflower and butterfly meadows surrounding woodlands that protect ironwoods, a native tree highly sensitive to the environment and fast disappearing from the Southeast. (Photo by P.E. Peters.)

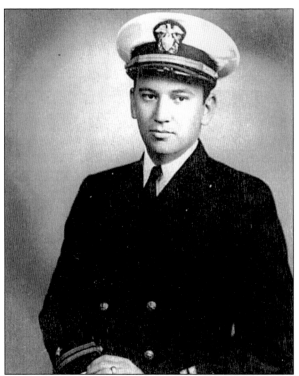

Born in 1913, Daniel Jonathan Stowe, youngest son to Robert L. Stowe (1866–1963) and Nellie Lee Rhyne Stowe (1876–1964), entered the U.S. Navy at age 29 in 1942. He served the duration of World War II. He returned to Belmont in 1946. He worked as secretary, then as assistant treasury, and later as director of Stowe Mills. He filled the same positions in his newly formed companies including Pharr Worsted Mills, Inc. A gardener in his spare time, Dan eventually retired. He donated money, time, and land for the botanical gardens.

On New Hope Road south of Belmont is Daniel Stowe Botanical Garden, also known as DSBG. Near the center of DSBG is Robert Lee Stowe Visitor Pavilion, a blend of architectural motifs under a copper roof. Its white columns are Tuscan in design. Its stained-glass dome in Founders Hall reflects a Roman heritage, and the contemporary structure serves as a 13,500-square-foot learning center for students and researchers as well as a conference facility for area businesses. Designed by the Richmond, Virginia architectural firm of Marcellus, Wright, Cox, & Smith, the Pavilion with its expanses of glass allows visitors to enjoy the full spectrum of the garden from one location. DSGB also offers trams for garden tours. The public entrance is at the north elevation; this view features the Pavilion's south elevation. (Photo by P. E. Peters)

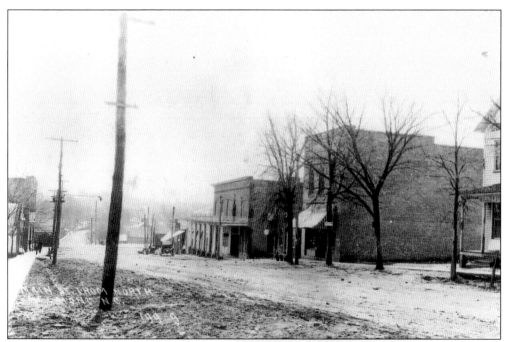

Main Street in Belmont in 1907 was rugged and well traveled, so George Gullick built this two-story brick hotel. It housed Stowe Mill offices and the Bank of Belmont until more contemporary structures existed. The hotel building still stands on 21–25 Main Street. Cherubs Restaurant operated by Holy Angels occupies part of the retail space of the Belmont Hotel. (Courtesy of the N.C. Division of Archives and History.)

Some things never change. Children climb trees in Belmont, just as Kathryne did in 1923. She is behind the Belmont Hotel, which employed her mother, Mary Ethel Teague Kennedy. (Courtesy of Juanita Kennedy Caldwell.)

A law school graduate left Mississippi and took his first job as Mount Holly's city attorney in 1949. The $75 per month paycheck sustained the family, and the attorney's young son Max matured into a writer. Presently, Childers is a professor of English at Winthrop University. His celebrated fiction includes *Things Undone* (1990), *Alpha Omega* (1993) and *The Congregation of the Dead* (1996), all published by Wyrick and Company. Other short stories can be found in *No Hiding Place: An Anthology* (1999, Down Home Press) and *Mr. Lee and Other Stories* (1995, Sandstone). From his home in Gaston County, Max continues writing about Southern rural life and rocky relationships.

Belmont has had other depots besides Garibaldi. This one designed by Charlotte architect Charles Christian Hook served Piedmont and Northern beginning in 1916. The rails and depot were part of the three-mile branch line extending from the Piedmont Traction Company's main line that was constructed between Charlotte and Gastonia in 1911. In 1987, Robert L. Stowe III purchased the depot property and entered into an agreement with the National Railway Historical Society, Piedmont Carolinas Chapter, Inc. that operates the structure as a museum. Outside exhibits consist of a 1951 GE 25-ton Diesel Electric Switcher from Duke Power's River Bend Plant, a 1951 Southern Railway X671 Caboose, and a 1955 Pullman Standard Sleeper Lounge. Other exhibits include equipment and a bench from Gastonia's Southern Railway Station. (Photo by P. E. Peters.)

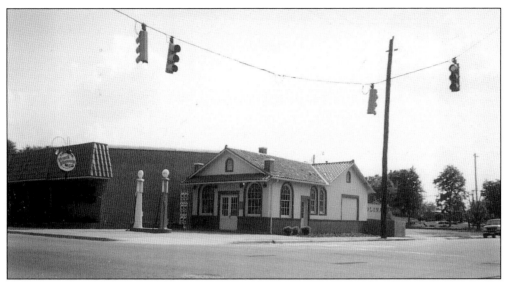

Three truck museums exist in the United States, and one is located at 117 North Mountain Street in Cherryville. It is C. Grier Beam Truck Museum, established in 1982. The museum stands by this Mission-style structure built in the late 1920s as a Shell gasoline station. It later served as an office for a two-truck freight operation that started in 1932 as Beam Trucking. In 1937 Beam reorganized as Carolina Freight Carriers. The firm steadily grew by acquisitions and mergers of other freight carriers. In 1995 Carolina Freight's offices closed in Cherryville and reopened in Charlotte as WorldWay Corporation. The museum, however, is still fun for adults and children interested in vintage big rigs. (Photo by P.E. Peters.)

Located at 109 East Main in Cherryville, this two-story, neoclassical brick municipal facility operated as the second city hall until the 1960s. Presently, the structure serves the Cherryville Historical Museum, which exhibits items pertinent to the development of the area. Within the museum is an advertisement of American Tobacco Company featuring the Durham Bull. There are only four such wall paintings known to have survived throughout the United States 'and Europe. Cherryville's Durham Bull was probably painted about 1910. It is pristine due to the plaster that covered the ancient paints for more than 80 years. (Photo by P.E. Peters.)

In 1976, Helen Marvin became the first woman from Gaston County to be elected to the State Legislature. She was the first woman senator to represent the old 25th Senatorial District of Cleveland, Lincoln, Gaston, and Rutherford Counties. She served from 1976 until 1992.

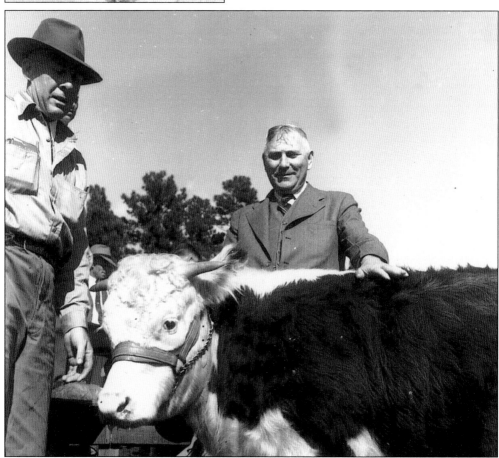

A veteran of World War I, Robert Gregg Cherry, an attorney, and his wife became the first people from Gastonia to occupy the Governor's Mansion in Raleigh. His term began in 1945 and ended in 1949. Democrat Cherry received 529,000 votes and his opponent Republican Fran Patton received 231,000. (Courtesy of the N.C. Division of Archives and History.)

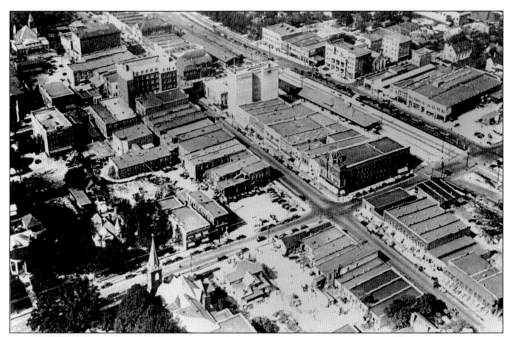

A plane flies over Gastonia after the end of World War II. Passenger and freight depots still stand beside the tracks. Armington Hotel dominates the upper portion of the image, and traffic is brisk on Long Avenue and Main Street. West Franklin Avenue is not depicted in the image.

In 1976 Gastonia operated under the guidance of its first African-American mayor, Thebaud Jeffers. In 1999 Jennifer Thomas Stultz of Gastonia became the city's first female mayor. She has a daughter, Amy McHenry, and two grandchildren, and she has been active in Gaston's communities since the 1970s. The *Gaston Gazette* newspaper named her "Person of the Year 2000." She is also the executive director of Gaston County Education Foundation. She is a 1998 nominee for Outstanding Women of North Carolina, and under her leadership, Gastonia was designated an All-America City in 2000. (Courtesy of the City of Gastonia)

In the 1950s, businesses purchased uniforms or equipment and sponsored Little League Baseball teams. Schneider's Department Store in Gastonia supported these ten boys, who are, from left to right, (front row) Steve Price, Bill Jarman, Calvin Beam, Eddie Manning, and Jim Stewart; (back row) Richard Stapleton, John Fisher, unidentified, Bobby England, Don Paysour, and Bob Perky, the coach. The boys practiced on Todd Field on Second Avenue behind the YMCA building on West Franklin Avenue. (Courtesy of Jim Stewart.)

When Joe Robinette posed for this photo, McAdenville Mill had closed and would be closed until 1939. The reason for closure has not been fully documented, but some historians think that the Great Depression and the advent of textile labor unions discouraged the mill owners. In this vintage image, Robinette shows his underhanded throw, a technique that entertained the villagers during their four years of hardship. (Special thanks to Rose Ann Christopher.)

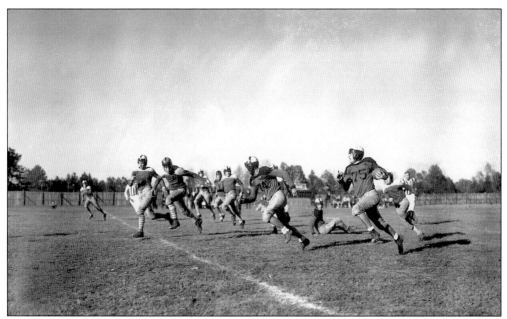

During the 1930s, a Belmont high school student could work the morning shift at the combed yarn mills, and then attend classes in the afternoon. He could play football after school or join his classmates in drama. Typically, a young man favored sports over arts. (Courtesy of the N.C. Department of Conservation and Development News Bureau and the N.C. Division of Archives and History.)

In 1938, Belmont cheerleaders celebrate a touch down. At the time, Belmont was a town that enjoyed a variety of social activities sponsored by local textile mills. By the end of the 20th century, the city's economy diversified, but school football games remain a favorite pastime. (Courtesy of the N.C. Division of Archives and History.)

Every New Year, families enjoy the performances and rituals of the Cherryville Shooters. Cherryville is believed to be the only U.S. town that regularly observes this European custom dating back to the Middle Ages when farmers remained apprehensive about a bad harvest if the fruit trees were not wassailed on New Year's Eve. Other historians point to the tradition as a symbolic episode designed to scare witches away from the community. In either case, the New Year's Day firing of muzzleloaders continues, and a monument to the shooters stands at Cherryville's Heritage Park. (Photo by P.E. Peters.)

McAdenville became Christmas Town U.S.A. in 1956. Charles Kuralt's *Sunday Morning* television show on CBS as well as a number of national magazines have featured the town's beautiful decorations inspired in part by this contraption that derives its energy from a water wheel. It is electric generator number 31. Written documentation can not verify that Thomas Edison personally installed the generator, but oral tradition maintains that Edison placed it within McAden Mill making the mill the first in Gaston to have electricity.

On the left is James (Cam) Campbell Stewart Jr. racing his buddy down Buckingham Street in Gastonia, c. 1968. Most neighborhood streets in Gastonia and throughout the county are safe, but many children prefer the play programs sponsored by the county's parks and recreation department. (Photo by Jim Stewart.)

Green spaces such as municipal golf courses and recreational parks dot Gaston's landscape. The county and its citizens strive to maintain a balance between growth and nature. Some fields have disappeared from the county due to heavy construction of houses, malls, and parking lots. Cramerton's golf course, depicted in this 1938 photo, initially provided fun for mill employees only, but now it serves as a community golf course for the public. (Courtesy of the N.C. Division of Archives and History.)

Five

CHANGES AND
CHALLENGES

A German Midget Submarine is displayed to a crowd before the courthouse. The end of World War II meant the end of Gaston's textile boom. The county began to diversify its income by recruiting new and different kinds of businesses.

A Cramerton farm truck is loaded with milk in 1938. In the background, the glittery South Fork flows without silt or weeds to meet the Catawba at the South Carolina state line. Some of the fertile fields and forests that once existed between the two rivers have been leveled and littered by real estate development. Most Gaston family-owned farms now lie north of I-85 and west of Highway 321. (Courtesy of the N.C. Division of Archives and History.)

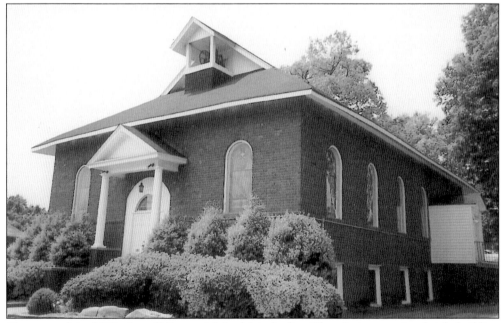

Constructed in 1901, Lowell-Smyre United Methodist Church is a quaint brick building surviving in the retail sprawl that is a part of the I-85 corridor. The Lowell church is a few city blocks from the Franklin Square Mall, built between 1996 and 1999. (Photo by P.E. Peters.)

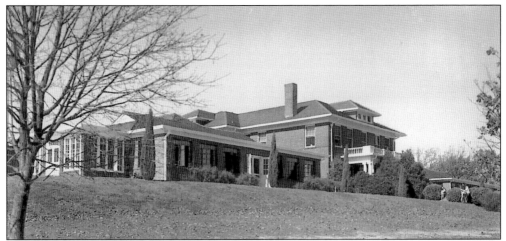

Beginning in 1909, Robert Benjamin Babington Sr. successfully lobbied the state for the formation of the Orthopaedic Hospital, which was constructed between 1920 and 1921 at 901 South New Hope Road in Gastonia. In the mid-1940s, it proved to be a godsend during a polio epidemic. Parents camped in tents on the hospital grounds while their young ones battled crippling paralysis. After the polio vaccine was discovered in the 1950s, the hospital served kids with spina bifida, clubfeet, and other disorders. It closed in the 1970s when Gaston Memorial opened a facility near I-85. Today, buildings of the Orthpaedic Hospital serve as offices for the county's social services department. (Courtesy of the N.C. Division of Archives and History.)

Gastonia's Erwin Park, constructed in 1945, is named in honor of Dr. Herbert J. Erwin Sr., an ardent sports fan. Dr. Erwin founded the first Gaston County Hospital for Colored People, but some African-American patients were treated at the Orthpaedic Hospital. Pictured are two patients playing in an iron crib in front of their nurse at the Orthpaedic Hospital in 1938. For the period, the state-funded Orthpaedic institute offered the finest in health care to the poor no matter their race or their religion. (Courtesy of the N.C. Division of Archives and History.)

Doctors L.N. Glenn, M.G. Anders, J.M. Sloan, E.M. Eddleman, and drug store owner Frost Torrence invested funds and established Gaston County's first hospital in this boarding house on Airline Avenue in Gastonia. It had nine beds. Within four years, the house proved inadequate. (Courtesy of Gaston Memorial Hospital.)

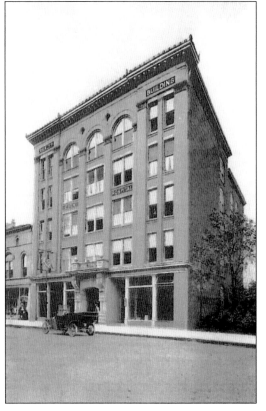

Medical staff relocated the hospital to the third floor of the Realty Building on Main Avenue in Gastonia. Population growth continued, so a new brick building was built on North Highland Street in 1924. This view appears on a 1910s postcard. (Courtesy of the City of Gastonia Downtown Development.)

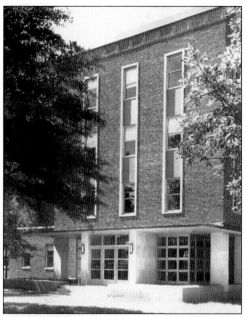

Gaston Memorial Hospital expanded in 1946 when Gaston Post 23, American Legion, initiated a public fundraiser to purchase Gastonia's City Hospital as a perpetually useful memorial to the Gaston County Veterans of World War II. The part of the hospital referred to as the City Hospital, built in 1924, provided 46 beds. In 1947 the hospital established a School of Nursing. About 307 women graduated from the first class. In 1973, the program ceased certification processes for nurses and trained volunteers for the hospital. In 1951 and in 1957 annexes were built, and Gaston Memorial served patients in a 223-bed facility. In 1997, the 1924 structure was demolished. Annexes, however, still stand on North Highland Street in Gastonia as part of Gaston County's administration offices. (Courtesy of Gaston Memorial Hospital and CaroMont Health.)

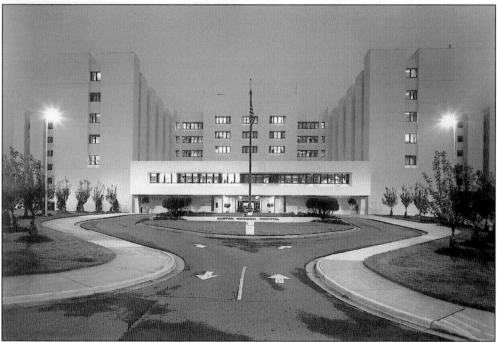

Under the leadership of Brown Wilson and Gaston Post 23, American Legion, the City Hospital became Gaston Memorial Hospital, a non-profit facility. In 1992 a four-level addition opened, expanding the Northeast Tower and doubling the size of the Emergency Department, featuring 28 treatment areas and a helipad for air transport. In 1993, Gaston Memorial became one of seven hospitals in the state to earn a Community Hospital Comprehensive Cancer Program designation from the American College of Surgeons. In 1998, the hospital began a Southeast Expansion Project, which will provide additional space for surgery, radiology, and laboratories. (Photo by Randy McNeilly; courtesy of Gaston Memorial Hospital.)

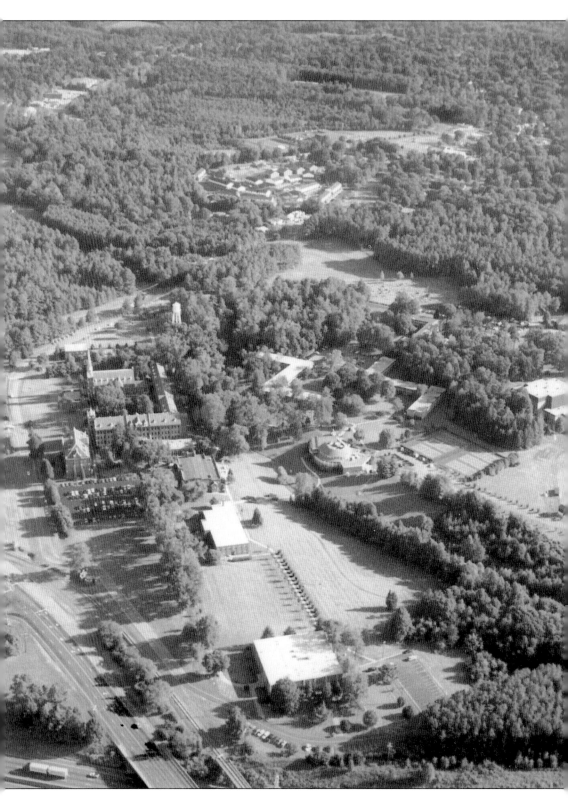

Adults interested in higher education can pursue it at Belmont Abbey College, a coeducational Catholic liberal arts college established on 600 acres by the Order of Saint Benedict in 1876. The bottom right edge of the image shows I-85, constructed from 1955 and widened throughout the latter half of the 20th century. In the top right corner of the image is the Catawba River. (Courtesy of Belmont Abbey College and Advanced Aerial Photography).

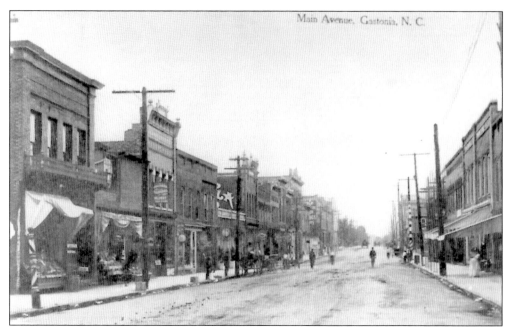

Before strip malls and deluxe shopping centers, Gaston villagers shopped on pedestrian-friendly main streets. If their town did not have items they needed, people drove a car, took a trolley or rode the train to Gastonia. Throughout the majority of its history, Gastonia and Gaston County have operated on a diverse economy unconstrained and virtually independent of manufacturing commerce east of the Catawba River. This postcard image was made *c.* 1906. (Courtesy of the N.C. Division of Archives and History.)

Born in 1911, Juanita Kennedy Caldwell keeps her sister Kathryne Louise company, *c.* 1923. The two sit on a carpet in front of the Frances House. During the 1920s, the girls enjoyed shopping at the county seat's boutiques whenever they could get Mother to take them. (Photo by Mary Ethel Teague Kennedy; courtesy of Juanita Kennedy Caldwell.)

Road construction altered Gastonia and the rural landscape. In 1961, Interstate 85 was extended into Gaston County. The highway completely bypassed Gastonia by 1962. Since travelers preferred the convenience of cars to trains few visitors ever saw the city limits or the boutiques that lined Main Avenue. Soon malls dotted the countryside between Franklin Boulevard and I-85. Within the decade from 1966 to 1976, Eastridge Mall became a destination for out-of-town shoppers. In 1997, Eastridge was refurbished as the population's shopping habits again shifted to pedestrian friendly places like renovated Main Street. This photo was taken in the 1970s. (Courtesy of the City of Gastonia Downtown Development.)

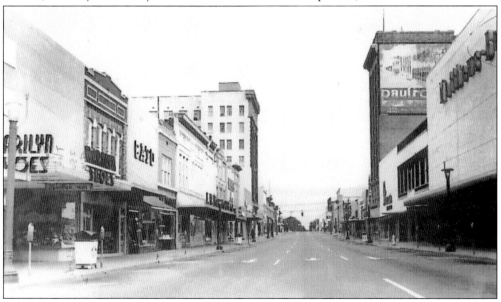

Parking meters are part of the past in Gastonia and most of the towns in Gaston County. Pictured is Gastonia's Main Avenue after contemporary updates were implemented in the 1970s. Town life continues to center around courthouse activities, but unlike some government centers, Gastonia offers plenty of free parking spaces for the general public. (Courtesy of the City of Gastonia Downtown Development.)

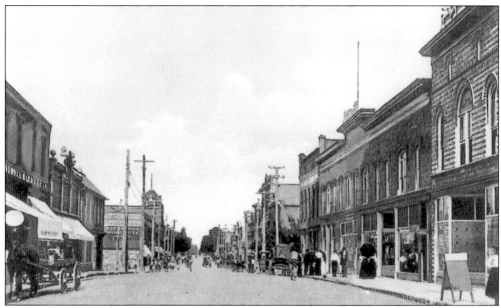

At the far right of this vintage postcard image is the Love Building in Gastonia. John Love's stores provided clothing, hats, shoes, and dry goods to Gastonia citizens. In 1896 he became an incorporator in association with George Gray, Thomas Craig, and T.W. Wilson, and the men created Avon Mills in Gastonia. In 1900 Love further diversified his income with help from George Gray when the two created their namesake Loray Mill. Gastonia's Frost Torrence, J.M. Sloan, and W.T. Rankin also held interests in Loray. (Courtesy of the N.C. Division of Archives and History.)

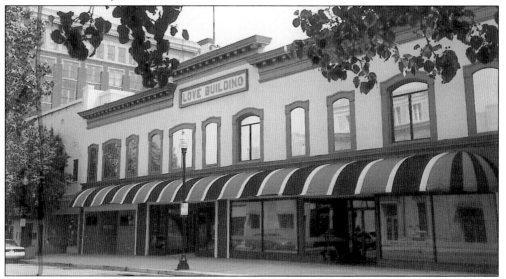

Built in 1904 by the son of textile leader R.C.G. Love, the freshly painted John F. Love Building in downtown Gastonia is part of a movement by the private and public ·sector to preserve historic architecture within the villages and towns of Gaston County. Since the 1980s, citizens of Belmont, Bessemer City, Cherryville, Dallas, Gastonia, McAdenville, Mount Holly, and Stanley have annually implemented plans to increase preservation efforts and to make the byways beautiful as well as pedestrian friendly. (Photo by P.E. Peters.)

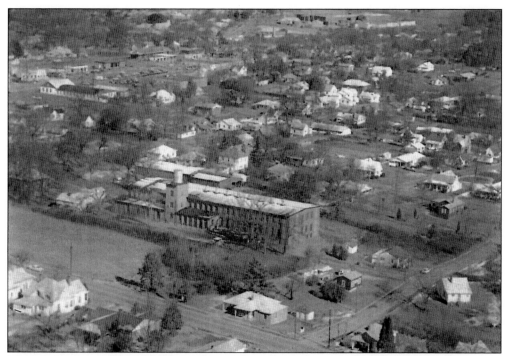

Mauney Cotton, or Gaston Mill, in Cherryville still stands in a town dedicated to preserving its heritage. This view, taken during the 1960s, reveals the village and the factory.

An island in an asphalt sea, Mount Holly Depot still stands on its original foundation within the reconstructed junction around 528 East Central. Abused by time and vandals, the building once served as the Piedmont and Northern Commuter Depot. It is a 1910 Mission-style depot complete with a red clay tiled roof. Its smaller cousin serves as a museum in Belmont. The depot, unlike the majority of Gaston landmarks, is in need of new owners since the county relies heavily on the private sector to preserve its historic structures. (Photo by P.E. Peters.)

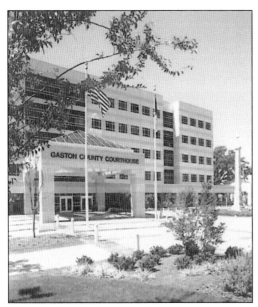

Now, the courthouse, designed by the local architects of Stewart·Cooper·Newell, is the focal point of Gastonia's downtown. This city block once held the Falls House and the Armington Hotel. (Photo by John Cooper, A.I.A.)

Born and raised in Gaston County, James (Jim) Campbell Stewart watches business partner John Walton Cooper seated at the company's first computer at the Chestnut Street office in Gastonia. Born in 1939 in Tsingtao, Shantung, China to two U.S. missionaries, John graduated from Clemson in the early 1960s, as did Jim. The two partnered in the early 1970s and have designed a host of structures. In 1996, the company of architects relocated to historic Second Avenue. There, they completed renderings for the Gaston County Courthouse, a design honored in *American Institute of Architects Justice Facilities Review 1996–1997*. Stewart·Cooper also designed the county's libraries, government complexes, schools, and churches. Kenneth Charles Newell of Clover, South Carolina became a partner in 1994, and in 1998, the firm became Stewart·Cooper·Newell Architects. (Photo by K. Hull; courtesy of the *Gaston Gazette*.)

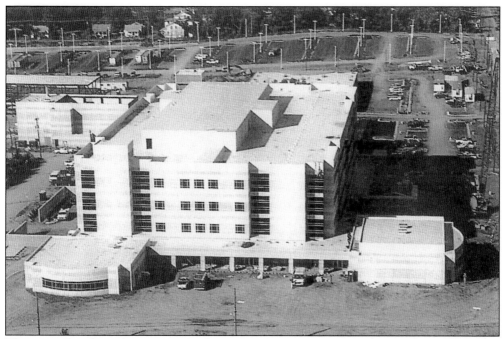

The groundbreaking dates to 1993 when a bond was approved for $38 million to complete the Gaston County courthouse. The government complex includes the courthouse, pictured here under construction. The complex sits on 13.5 acres beside Long Avenue, which is also a part of Highland Historic District. The courthouse was dedicated June 20, 1998. (Courtesy of Stewart·Cooper·Newell Architects.)

Gastonia Municipal Airport is located on Union Road just outside the City of Gastonia. It was completed in 1945 on a 300 acre tract of land. It offers two runways for small planes. The lighted runway is about 3,500 feet. The one unlit runway is roughly 2,500 feet. The facility also features air shows for the general public. (Photo by P.E. Peters.)

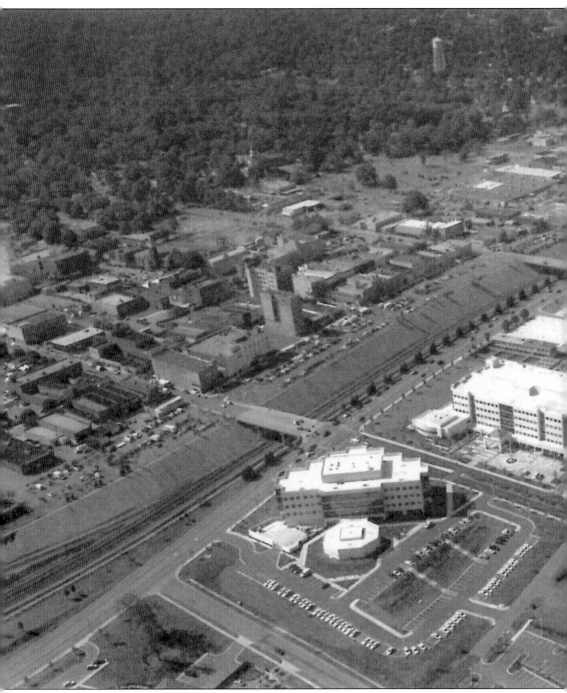

In a recent *Charlotte Observer* article, Gaston author and historian Lucy Penegar wrote, "Historic preservation is the ultimate recycling." Preserving the area's architecture and landscape can attest to the optimism or the hardships of an innovative people. Gastonia and Gaston County residents continue to preserve their rich heritage through public and private resources. Neighborhoods in Belmont, Bessemer City, Cherryville, Cramerton, Dallas, Gastonia, High Shoals, Lowell, Gastonia, High Shoals, Lowell, McAdenville, Mount Holly,

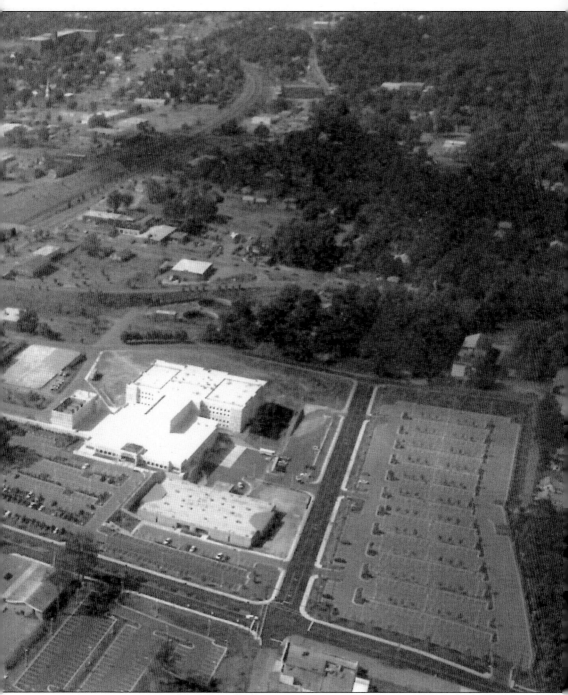

Ranlo, and Stanley strive to complement the old with the new. Through libraries, museums, and discovery centers, Gaston County progresses in its effort to educate children and adults. This is the challenge as well as the opportunity faced by the people of Gaston County, both now and in the future. Pictured is Gastonia's town center featuring the historic district and new architecture that serves as the government complex. (Courtesy of Stewart·Cooper·Newell Architects.)

ACKNOWLEDGMENTS

This book would not have been completed without the generosity and support of Carol Reinhardt and the staff of Gaston County Library; Steve Massingill at the North Carolina Division of Archives and History in Raleigh; Keith Longiotti and Jerry Cotten at the Wilson Library, University of North Carolina at Chapel Hill; Martha G. Elmore in charge of Special Collections, Joyner Library at East Carolina University; Beth Bergar and P.T. at Belmont Abbey College; Stephanie Michael-Pickett at Gaston College; Rick Haithcox and Donald McGinnis of Haithcox Photography; Dereama Harris and Barbara Lawrence of Downtown Development, City of Gastonia, Inc.; James (Jim) C. Stewart, John W. Cooper and the American Institute of Architects in Raleigh; Laura Joyner of Gaston Memorial Hospital; and lastly, Juanita Kennedy Caldwell and Heather Parrish.

Space limitation prevents complete listings, but access about items researched can be obtained through library search engines. You can type the author's name(s) or the subject matter, which could include keywords like Gaston, Gastonia, Catawba River, Textiles, etc. I am most appreciative of the printed works by James W. Atkins, Dom P. Baumstein O.S.B. and Debra G. Estes, Dave Baity, LeGette Blythe, Kim Withers Brengle, Robert F. Cope and Manly W. Wellman, Wilma Dykeman, Frye Gaillard and Dot Jackson, Sally Griffin, Elizabeth Hess, S.H. Hobbs Jr., Michael D. Jones, David Kelley, Dr. Elisha Mitchell, Rev. Dr. J.J. O' Connell O.S.B., Lucy Penegar, Leigh Pressley, Liston Pope, Minnie S. Puett, Joseph H. Separk, Beth L. Smith and Ashley Garner, Ken Sanford, Sheri Sellmeyer, Howell Stroup, R.L. Stowe Sr., Charles Wetzell, Sharon E. White, Bill Williams, Robert L. Williams, and Ross Yockey.

A number of periodicals were studied. These include Gaston County Historical Association's bulletins, *Clarion* yearbooks of Belmont Schools, and corporate profiles from *Southern Textile Bulletin*, *Labor Defender*, and *Textile Review*. *Our State* magazine, *Belmont Banner*, *Gastonia Daily/Gaston Gazette*, *Daily Worker*, and the *Charlotte Observer* provided a variety of informative articles. Trade papers, corporate annual reports, documents from the Library of Congress and U.S. Census data accessed via the Internet were incorporated into the research process as well. To Richard L. Aheron, Max Childers, Rose Ann Christopher, Lou Ann Cooper, Laura Daniels, Don McGinnis, and Rick Haithcox—your encouragement lifts me, your friendship comforts me, and your talents amaze me. Thank you for making this book project a joy.